happy hand lettering

SIMPLE CALLIGRAPHY TECHNIQUES
TO BRING YOUR WORDS TO LIFE

jen wagner

NORTH LIGHT BOOKS
artistsnetwork.com

D1268641

Contents

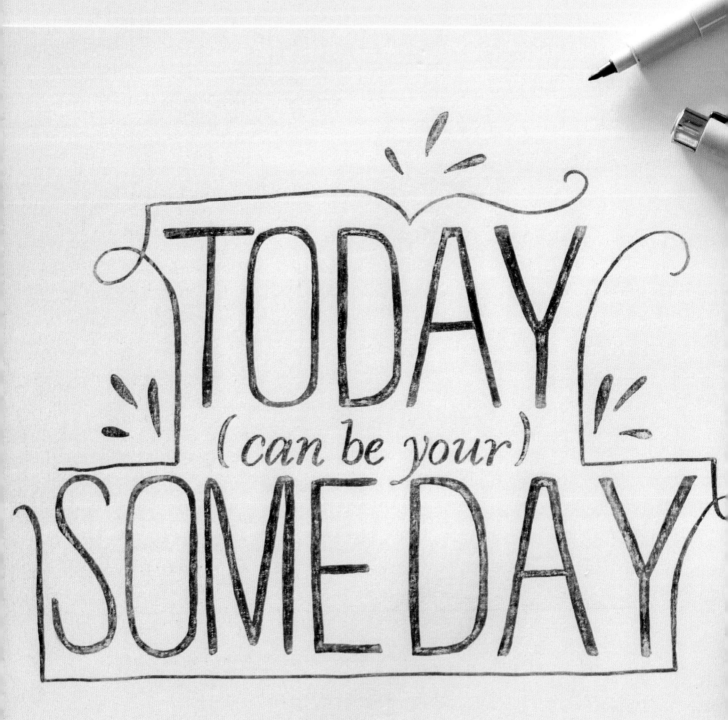

TODAY *(can be your)* SOMEDAY

The Joy of Learning Something New

IN 2014 my husband and I started doing something every day called "5am Club." We would each wake up at five o'clock in the morning and spend the first two hours of the day intentionally learning something new. It was a struggle, at first, to figure out what I wanted to spend the time doing. After all, that's another two hours in the day I could spend working on something "more important!" E-mails still needed to be responded to, websites still needed updating, dishes still needed to be done . . . there's always something more! It was, however, our agreement that we would spend that time on something we enjoyed. So, after scrolling mindlessly through Pinterest, wondering what I could possibly want to devote this extra time to, I spotted a lettered quote and thought, *Now that could be fun to learn!* And so my exploration of hand lettering began.

Lettering throughout the years has become very therapeutic for me. There are some seasons when you feel in control of your life and others when it seems like life is just happening to you—and you're not alone! I think that's just the general gist of life: Ups and downs are completely normal and they offer the opportunity to bring us all together as a community.

• • •

There are two ultimate goals I have for this book. First, I would love for you to be able to thoroughly enjoy the process of learning something new—and learning it for *you*. Don't learn so you can open an Etsy shop or start selling quote packages on Creative Market. Learn because you deserve to do something for yourself today.

Second, I want written words of encouragement to spread around your community like wildfire as you feel empowered to share beautiful messages of hope. A handwritten note goes a long way and, in my experience, making those notes beautiful gives me incentive to share them more often.

So let's agree through this process that our words are powerful, we are capable of delivering hope to those around us and we refuse to keep our encouraging words bottled up.

Let's get started!

Tools and Supplies

GENERAL MATERIALS

This list includes the basics you will need to complete the lettering exercises on the pages to follow. I've included my personal preferences, but experiment with different brands and types to find what works for you.

Brushes

- *Spotter Brush* – I love this brush for loopy lettering and pretty styles. I use a Robert Simmons S85 spotter brush size 5/0.
- *Flat Shader Brush* – This brush can create nice contrasting lines in your lettering. It's characterized by its flat (not pointed) bristles. I use a Robert Simmons size 1.
- *Round Brush, Large* – (optional) I love this brush for my watercolor decorative elements. I'm using a Royal & Langnickel Z73R round brush size 6.

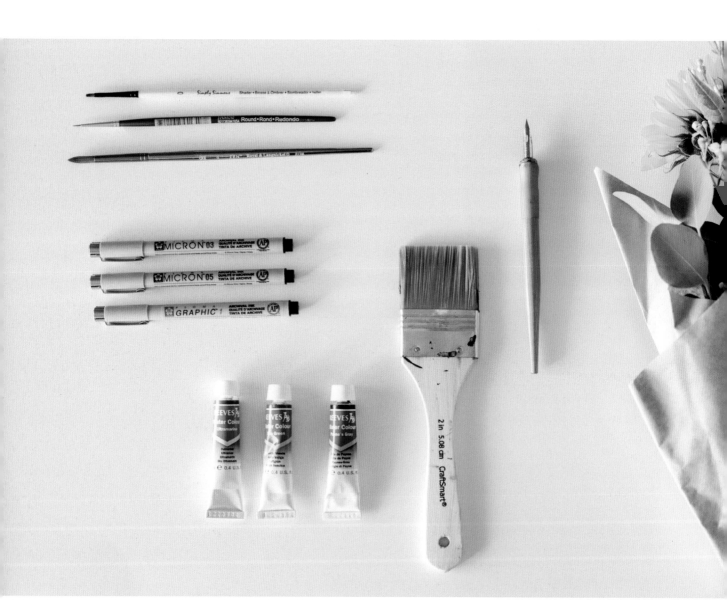

Calligraphy Ink – Speedball India ink works well for nibs if you're looking for an option to buy in-store; however, Sumi Calligraphy Ink has rapidly become my favorite. It writes well, has beautiful depth and comes with a little dispenser.

Ink Bottle, .5 oz – This is perfect for when you want to use only a small quantity of ink at a time. The high walls make it easier for dipping than a watercolor pan, although you can use a watercolor pan for your ink.

Nib Holder – Many calligraphers use oblique nib holders that hold the nib at an angle; however, I prefer mine to feel more like a pen, so I use a manga cartoonist nib holder. It all depends on what makes you the most comfortable and confident.

Nikko G Nibs – I've found these nibs are the easiest for beginners. They are flexible enough to create beautiful shapes but not so flexible that the ink gives you trouble.

Paper – We'll be using practice paper, tracing paper and 110-lb. (231gsm) cardstock.

Pencil and Eraser – Use what works for you, in addition to a 4H. White erasers will not leave color behind on your paper.

Pens
- *Brush Pens* – These pens are amazing for practicing brushstrokes. They feel slightly different from a watercolor bristle brush and the style ends up being a little different, so I prefer to use them for practice.
- *Gel Pens* – Wonderful for writing on dark colors or to use for embellishment.
- *Krylon Gold Leafing Pen* – I use this pen for most of my personal projects. It writes beautifully over watercolor and has the perfect amount of shine.
- *Sakura Pigma Graphic Marker* – This marker is one of my favorite tools for envelopes and creating a quick, simple calligraphy look. It's completely opaque, waterproof and writes easily so you can use it in conjunction with watercolors.
- *Sakura Pigma Micron Pens* – These pens are waterproof, very dark and super versatile. I've found them to be the easiest to create modern lettering with.

Tools
- *Scissors*
- *Straight Edge*

Watercolor Paints – I prefer condensed liquid watercolor paints; they're much easier to mix.

Watercolor Palette – Mix your watercolor paints in a watercolor palette for a clean option that keeps your actual colors from mixing (especially if you're using solid watercolors).

PROJECT MATERIALS
The latter part of this book offers you projects to try out your new skills. This is a general list of what we'll use as surfaces or tools to complete these fun projects. Additional material lists accompany each project.

Adobe® Photoshop® software | Digitizing
Envelopes | Envelope Project
Butcher paper roll/mount | Butcher Paper Menu Project
Gift tags | Gift Tag Project
Blank cards | Thank-You Card Project
Coffee mug | Coffee Mug Project
Oil paint pen | Coffee Mug Project
Oven | Coffee Mug Project
Wood board | Decorative Sign Project
Computer and projector | Wall Mural Project
Acrylic paint | Wall Mural Project
Paintbrushes, assorted sizes | Wall Mural Project

Desk Setup

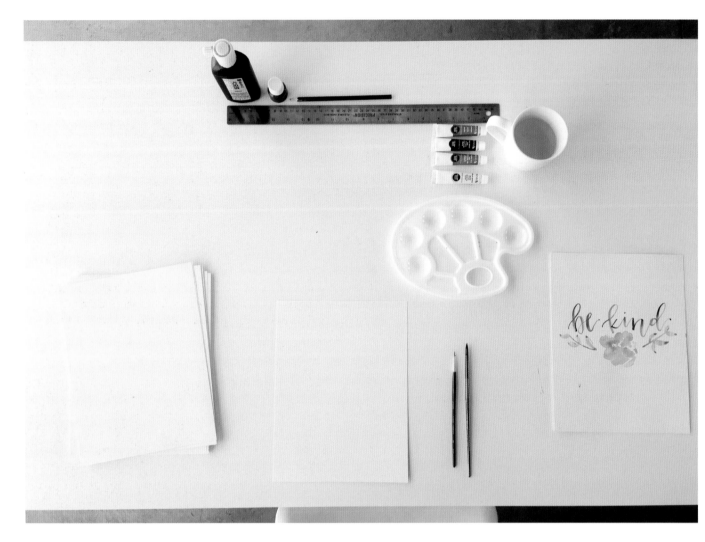

Setting up your desk is an element of lettering that is often overlooked at the beginning. I know you want to jump right in, but the setup is actually a quick and important way to help organize your workflow!

The way I set up my desk is the result of a few years of wondering why my process felt so unorganized and time-consuming! A properly arranged desk will improve your workflow, help keep you mentally organized and make your materials much easier to keep track of.

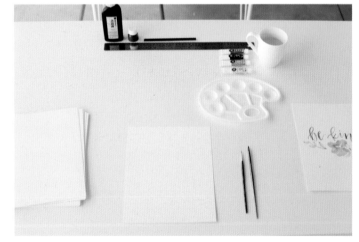

Let's say I'm working on lettering a limited-edition run of prints, and I'm right-handed (lefties, it may be easier to flip the setup). Right in front of me is my work space. This is where the current piece being worked on would sit.

To my left, I keep all of my blank sheets of paper stacked and ready to be brought over to my main work space in front of me to be lettered.

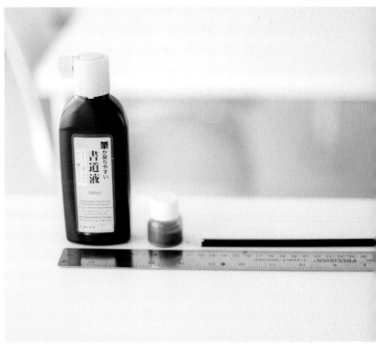

Above my work space, I keep extra brushes, pens, ink, my pencil/eraser and other tools I may need to grab. The key here is accessibility. Keep these things out of your work space to avoid clutter.

To my top-right, I keep my watercolor pan, a cup of clean water and any paints I'm currently using. That's it! Keep any extra materials you might need above your work space.

To my right, my space is entirely clear except for the writing utensils that are currently in use. Any writing utensils that I may use for accents or finishing, I keep above my work space out of the way. It's extremely important to keep this space clear because of how much movement occurs here, from picking up brushes to moving final pieces over to dry. You don't want to spill anything on your beautiful finished work!

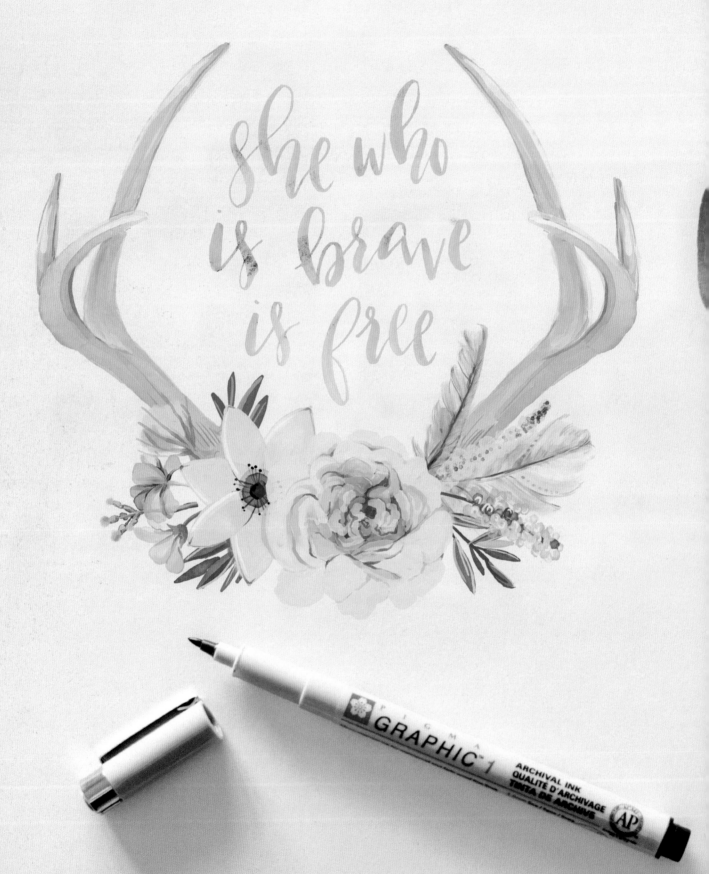

Typography

Knowing a few things about typography will go a long way in supporting your lettering creations. This section explores basic terms, as well as some tips on using kerning, varying baselines and thinking about composition.

Terms to Know

Here are some of the basics of typography. These terms will help you understand what we discuss in later chapters and also give you some insight into how you can improve your lettering with practice. Examples on the following pages show how some of these elements can dramatically change the look of your lettering.

Ampersand
The symbol for *and*.

Arm
The arm of a letter is the horizontal or upward stroke on some characters that does not connect to a stroke or stem at one or both ends.

Ascender
The upward vertical stem on some lowercase letters—such as *h* and *b*—that extends above the x-height.

Baseline
The baseline is the imaginary line where the bottom of your line of text will sit.

Cap Height
The height of a capital letter.

Italics
An italic letter is more than just a slanted letter. Real italics have qualities about them that are completely unique, such as rounded serifs and extra curves.

Leg
The short, descending portion of a letter.

Descender
The portion of some lowercase letters, such as *g* and *y*, that extends or descends below the baseline.

Kerning
The amount of space between each letter. Kerning can completely change the look of your lettering in an instant.

Serif
The extra strokes near the bottom and top of letters in certain typefaces. This contrasts with sans serif typefaces, which have no extra strokes.

Descender Line
The invisible line where the lowest part of your descenders will sit.

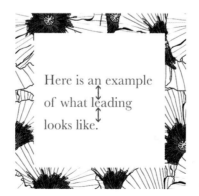

Leading
The amount of space between each line of text.

X-Height
The height that lowercase letters reach based on the height of lowercase *x* (excluding ascenders and descenders).

Comparing Kerning and Baselines

Illustrated below, we can see just how big of an impact differences in kerning and the placement of a baseline can have on the style of your lettering!

Change things up a bit by switching from tight kerning to kerning that's a bit more loose, or a straight baseline to a varied one.

KERNING

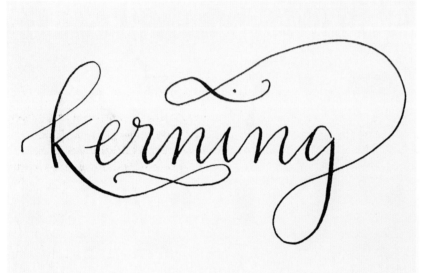

Tight
Tight kerning can take your elegance up a notch by offering great rhythm and consistency to the eye. I generally use tight kerning for the address on lettered envelopes.

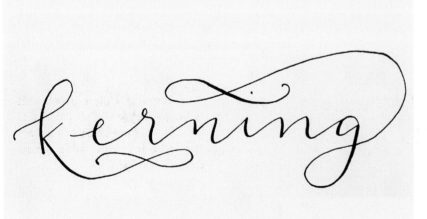

Loose
Loosening up your kerning is a very quick way to add freedom and breathing room to your words. I prefer loose kerning when lettering names on place cards and envelopes.

BASELINES

baseline

Straight
Straight baselines can be beautiful, refined and the perfect style for many different settings. I prefer straight baselines for addresses, weddings and elegant settings.

baseline

Varied
A varied baseline can be elegant as well! Notice here that none of the letters rest on a consistent invisible line. They simply float and fly, making this style a bit more fun and whimsical.

Composition Blocking

Blocking is a fantastic technique that can make your word arrangement much simpler to figure out. It creates visual aid to guide your word composition and get your arrangement just right. Let's explore this technique!

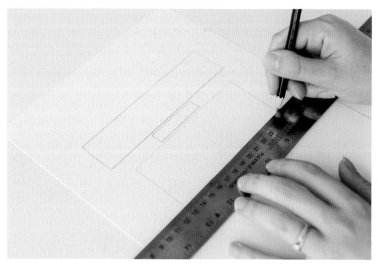

1 To start, use a straightedge and a pencil to create blocks that will contain your words. In this example, I have the top block reserved for the words *You Are*, the middle block reserved for *the*, and the bottom for *Best*, each sized the way I'd like the words to be in my final composition.

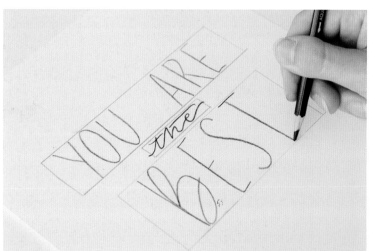

2 Next, take a pencil and lightly fill your blocks with your words. Keep in mind that dark pencil will show a bit through watercolor, so adjust according to which lettering technique you plan on finishing your piece with.

Use the top lines of your blocks to help guide your letter height and the side lines of the blocks to help guide your kerning. Blocking will help you center and size your words properly with practice, so don't be afraid to experiment and mess up sometimes. After all, you can always erase pencil and try again!

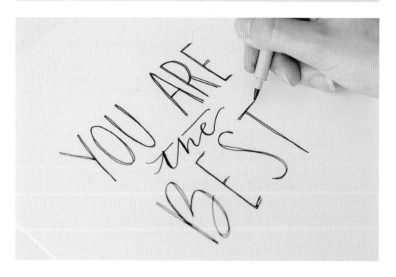

3 Once your penciled words look the way you want, trace over them with a marker, brush or other writing utensil. This technique is great for any of the projects we'll discuss in following chapters, so feel free to use whatever writing technique you like.

COMPOSITION EXAMPLES

One of the most important things to consider before you begin lettering is how you'll compose your piece. There are several main elements of composition to consider, and we'll briefly address each before diving in.

Contrast

Contrast seeks to answer the questions, "Does your lettering blend into the page/composition? How can you make it pop?" When you learn how to digitize your lettering, it can be fun to place it on different backgrounds; however, you want to make sure there's enough contrast so your letters don't disappear into the busyness of your background.

Focus

Focus seeks to answer the questions, "What is the key word in your phrase? Is it the focal point of your piece?" If there is a word you'd like to emphasize, make sure the focus is drawn to it by making it bigger, a different color, different style or by having other elements point to it.

Movement

Movement seeks to answer the question, "Does the movement of your letters make sense for the type and content of your artwork?" This piece was intended to be simpler without emphasis on certain words, so the movement is consistent among every word to create a sense of unity throughout the art.

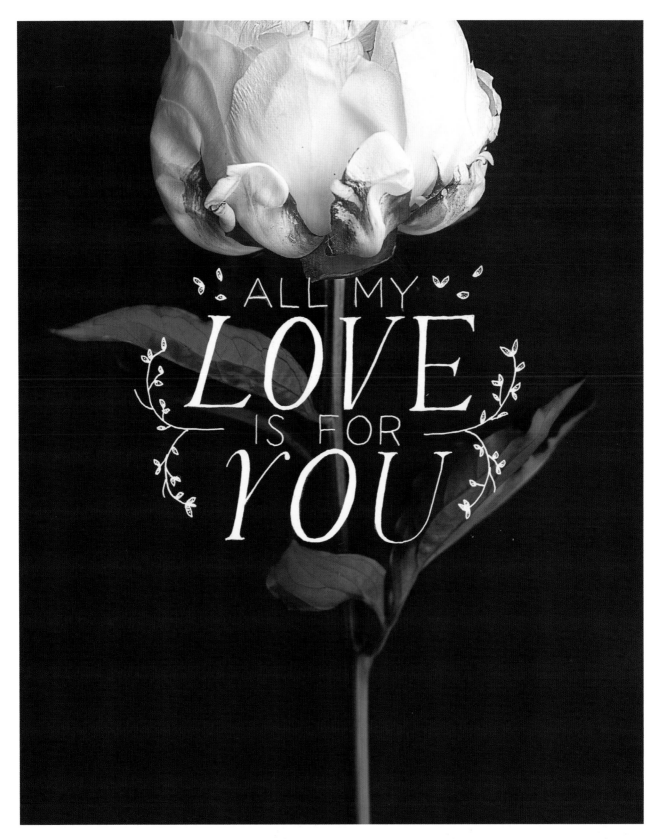

Proportion

Proportion seeks to answer the questions, "Do the words in your phrase fit together? Are the small words legible? Do the large words distract from your focal point?" The example here utilizes proportion to emphasize the words *LOVE* and *YOU* without letting the message get completely lost among the smaller words.

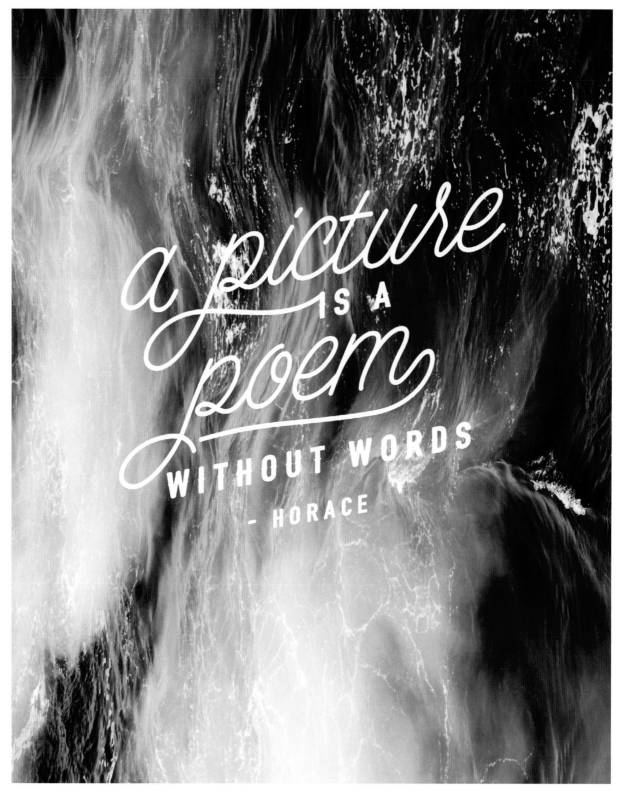

a picture IS A poem WITHOUT WORDS
– HORACE

Rhythm

Rhythm seeks to answer the questions, "Is the movement of your letters and phrases consistent? Does it help lead the eye?" A good way to create consistent rhythm is to make sure your emphasis words are the same size as one another and your filler words are the same size as each other. For example, the words *a picture* and *poem* are the same size, and *IS A* and *WITHOUT WORDS* are the same size as well. This helps guide the eye through the piece while placing emphasis where it belongs.

Unity

Unity seeks to answer the questions, "Do all of the elements belong together? Do any additional decorative elements, colors, etc. make sense in the piece, or do they simply not fit?" It's important to make sure every element of your piece belongs. For example, this piece ties consistent colors and a certain element of delicacy together to create a piece with great unity.

hello

YOU AR

the

BES

Creating a
Calligraphy Look

Creating a calligraphy look doesn't always require fancy tools. In fact, you can create this look with your own normal printed handwriting! In this section, we'll learn how to take your normal printed handwriting and give it contrasting strokes to create your calligraphy look.

Getting the Look with Printing

Creating a calligraphy look with your printed letters is the perfect place to start learning the basics of calligraphy. The most defining element of calligraphy is the contrast of your strokes. Refer to the image here. Do you notice how there are both thick and thin lines used throughout the word? It's this line contrast that makes the most immediate difference between normal writing and a calligraphy look.

WHAT YOU NEED

pen of your choice
pencil
practice paper
straightedge

1 Using a straightedge and a pencil, create your guides for your written piece. This can include just a baseline, like what I did, or you can add your x-height line and ascender line. Add whatever lines will help guide you the most!

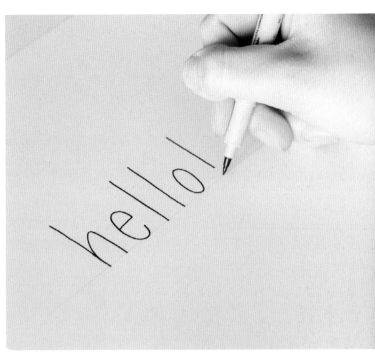

2 Using your writing tool of choice, write your word(s) in print. I chose to space my letters out a bit instead of keeping them close together.

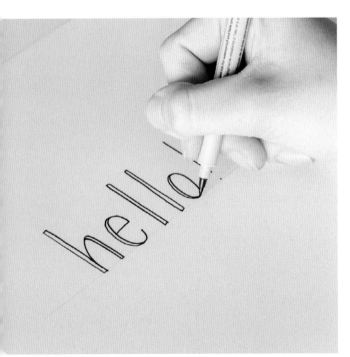

3 Next, identify and thicken your downstrokes. The downstroke happens any time your pen moves down the page, from top to bottom, as you are writing your word. For the letter e, for example, the stroke goes across, up to the X-height line, and then curves down around to the baseline. This downward curve is where my downstroke is located. Connect an extra stroke to each of your downstrokes as illustrated above.

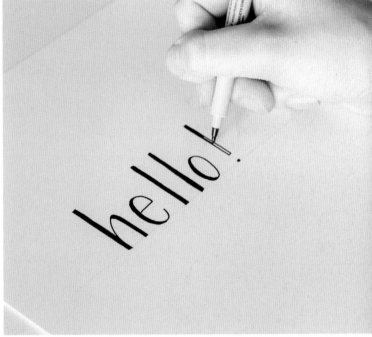

4 Finally, fill your downstrokes to create your contrasting lines.

Place Cards, Version I

Print lettering is such a versatile way to make your work look completely custom and beautiful without having to invest too much time. Here is an example of how to make great place cards using the printed method.

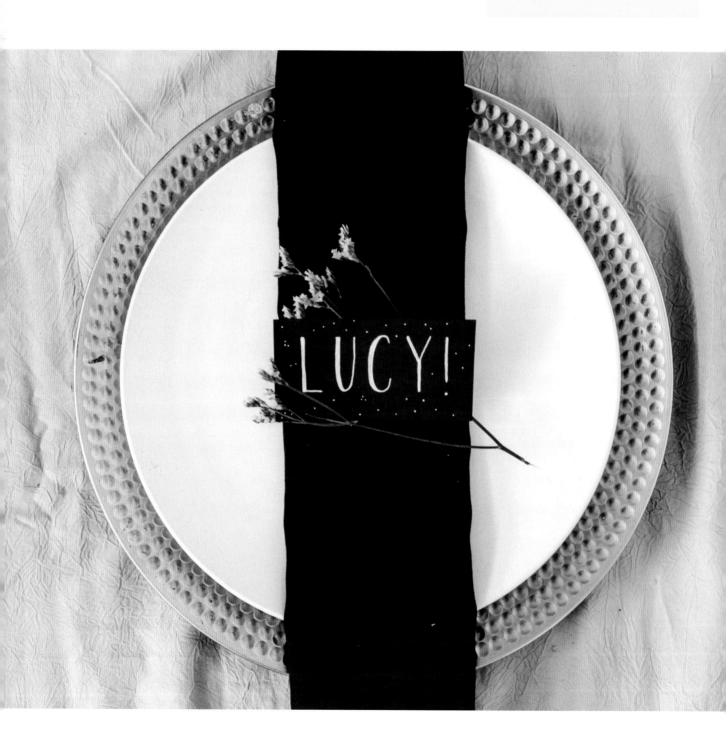

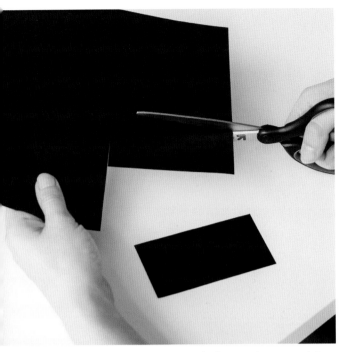

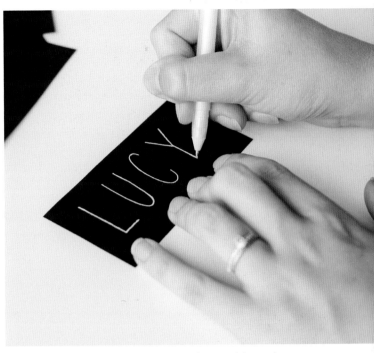

1 To create your printed place cards, first cut the appropriate size and amount of place cards from your choice of paper.

2 Next, write out each name on your place card. It may be helpful to lightly use pencil to create guides for your baseline and cap height line. This will help keep your letters straight and even.

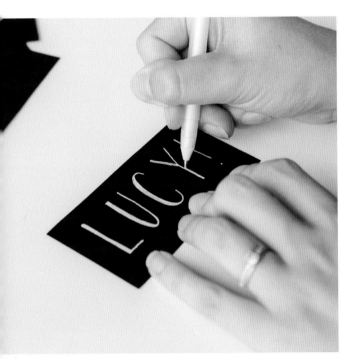

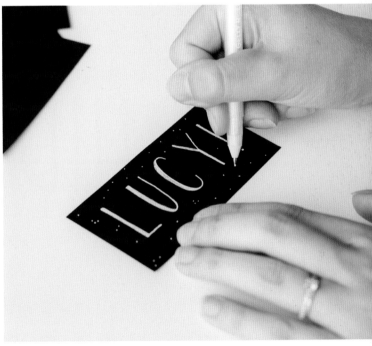

3 From one side of the name to the other, thicken each down-stroke until you're happy with the line contrast.

4 Finally, add some light decorative elements. I loved the idea of a constellation look for these black place cards, so I added some white dots around the name.

Note Cards, Version I

I absolutely love how simple it is to use print lettering for cards! It's a quick and simple way to personalize your messages and make sure your recipients feel like they're getting something special. Making custom cards is another way to use your print lettering to encourage others!

WHAT YOU NEED

folded blank card, white
markers, a few different colors
pencil (optional)
straightedge (optional)

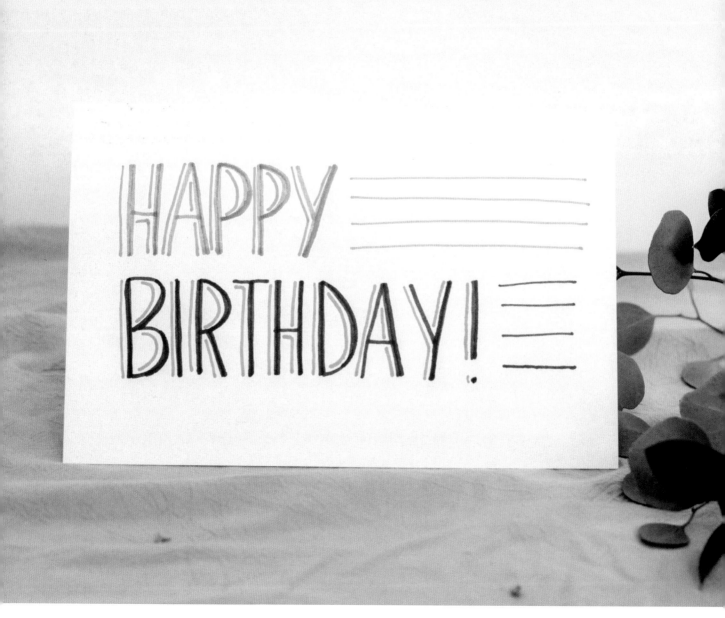

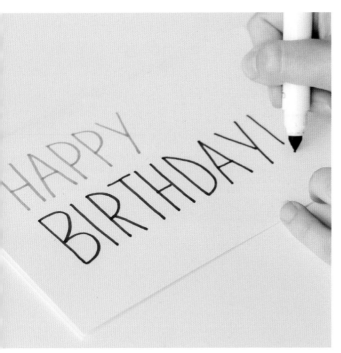

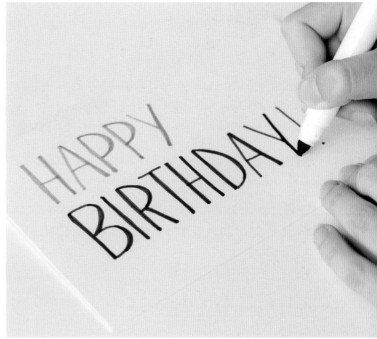

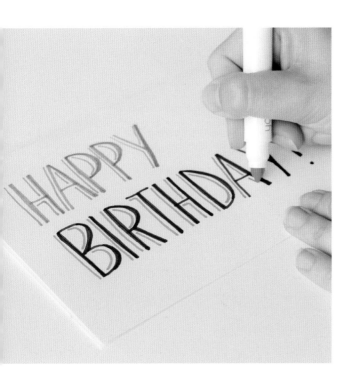

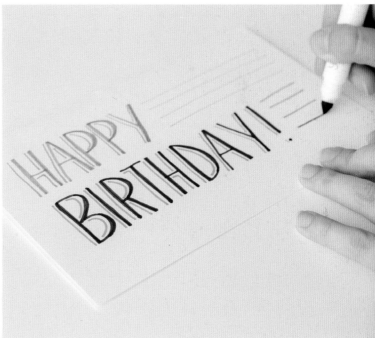

1 To make your printed card, start by writing your message in the writing tool of your choice. I used basic markers in a few different colors. It may help to create some guides for your words lightly with a pencil. This will help keep your words straight and consistent.

2 Next, thicken each downstroke using the appropriate color marker. I didn't want my letters to have a ton of contrast; however, you can make yours look more dramatic by thickening those strokes more and more.

3 Create some visual interest by adding decorative elements to your card. I added a simple second line, in a new color, for each letter.

4 Finally, I filled in the remaining white space with some colorful stripes extending to the end of the page.

Getting the Look with Cursive

Now that you're more comfortable identifying your down-strokes and forming your lines, let's move on to using our cursive handwriting for our letters.

Have fun with this quick technique that transforms your cursive handwriting into beautiful calligraphy!

WHAT YOU NEED

pen of your choice

pencil

practice paper

straightedge

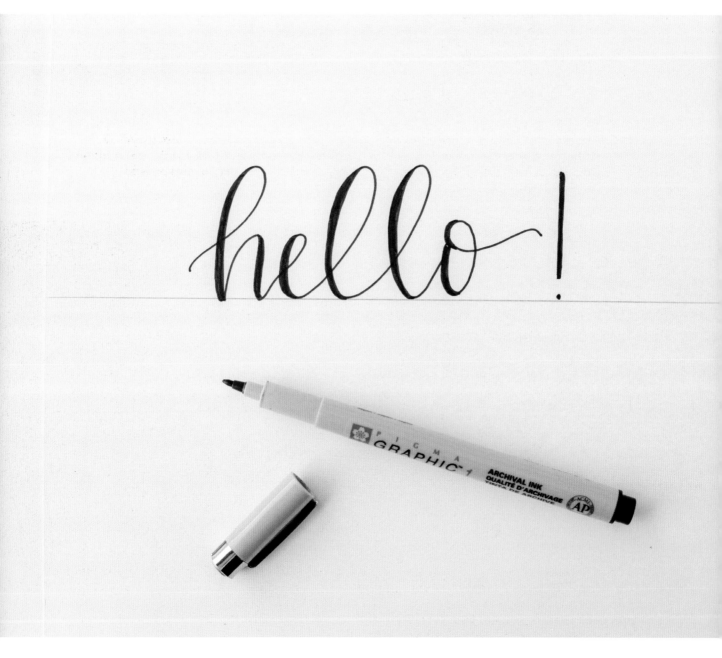

1 Using a straightedge and a pencil, create your guides for your written piece. This can include just a baseline, like what I did, or you can add your x-height line and ascender line. Add whatever lines will help guide you the most!

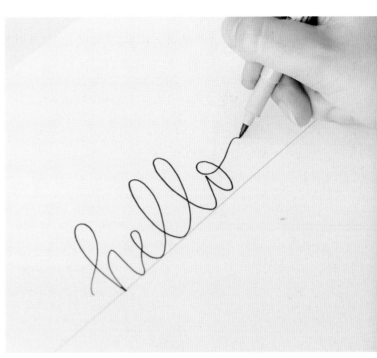

2 Using your writing tool of choice, write your word(s) in cursive. This doesn't have to be perfect. Even messy cursive handwriting can look beautiful with this technique.

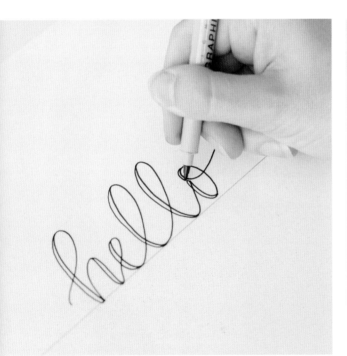

3 Next, identify and thicken your downstrokes. The downstroke happens any time your pen moves down the page, from top to bottom, as you are writing your word. For the letter *l*, for example, the stroke goes up to the ascender line then curves around to go down to the baseline. This downward curve is where my downstroke is located. Connect an extra stroke to each of your downstrokes as illustrated above.

4 Finally, fill your downstrokes to create your contrasting lines.

Place Cards, Version II

Custom place cards can be a quick way to add a personal touch to dinners and events. I made place cards for everyone's seat last Thanksgiving, and every single person asked if they could take theirs home! Let your guests know you thought of them specifically, and practice your newly found calligraphy technique with these fun place cards.

WHAT YOU NEED

cardstock, dark color of your choice
metallic marker, gold
pencil (optional)
scissors
straightedge (optional)

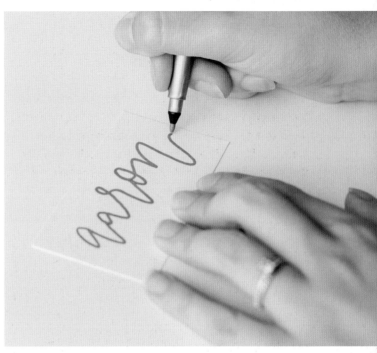

1 To make your place cards, first cut the appropriate size and number of cards from a single sheet of paper (you can also buy pre-sized cards if you like). It's helpful to keep the size consistent so you can more easily get into a groove once you start. Differing sizes can throw you off if you're making more than just a few!

2 Write out the name in loose cursive, using a varied baseline for your letters.

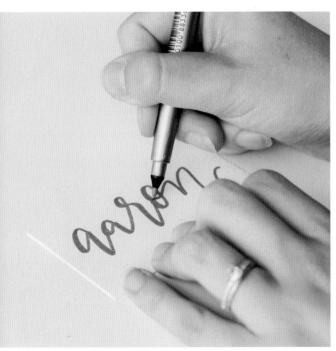

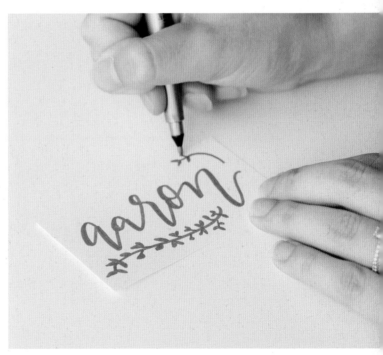

3 This is where we begin applying our "fake calligraphy" technique. From one side of the name to the other, thicken your downstrokes. The contrast between your upstrokes and downstrokes can be as extreme as you like. Thicken your downstrokes more and more until you love what you see!

4 (Optional) Finally, add some decorative elements to provide visual interest to your place cards. They look great without decorative elements as well; however, I usually add them to help tie the cards together with whatever theme I'm using the cards for. For example, my Christmas place cards would feature snowflakes, holly or other seasonal elements.

Note Cards, Version II

I've found that, in my family and friend groups, handmade cards carry a significant amount of meaning and value to the recipients. It doesn't always have to be perfect, but knowing that you put the time and thought into making something just for them is so special.

WHAT YOU NEED

folded blank card, white
markers, one or two colors
pen of your choice
pencil (optional)
straightedge (optional)

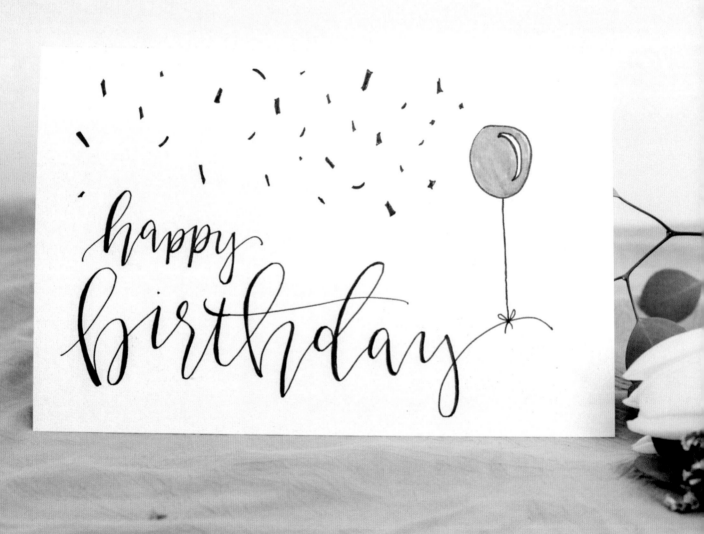

1 To create your card, begin by writing your message in marker or other writing utensil. To make this step easier, lightly write your message in pencil and revise until you're happy with it. Then, trace over the pencil with marker or pen.

2 Next, identify each downstroke and, from one side of each word to the other, thicken each until you are happy with the line contrast.

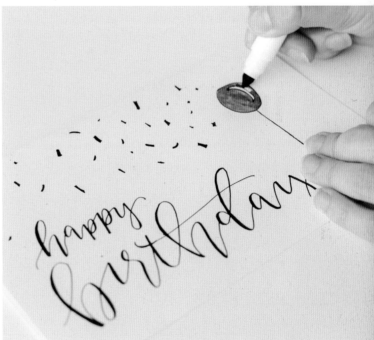

3 From here, you can add some fun decorative elements to create visual interest. I added a balloon and some confetti to my card to go along with the birthday theme.

4 Don't be afraid to add a little color! Enhance the look of your card with color, texture and other fun elements.

Lettering with a Brush

Lettering with a brush is one of the main techniques used for many of the trendy lettered posters out there right now. Although it takes a bit of practice, brush lettering is a beautiful and fun way to create custom quotes, cards, posters and so much more!

The Spotter Brush and the Flat Shader

If you've ever been to the paint section of a craft store, you know there are hundreds of types of brushes out there. So which are best for lettering? I actually use only two types of brushes—the spotter brush and the flat shader brush. Try playing with each as we work through the exercises in this section to get a feel for each.

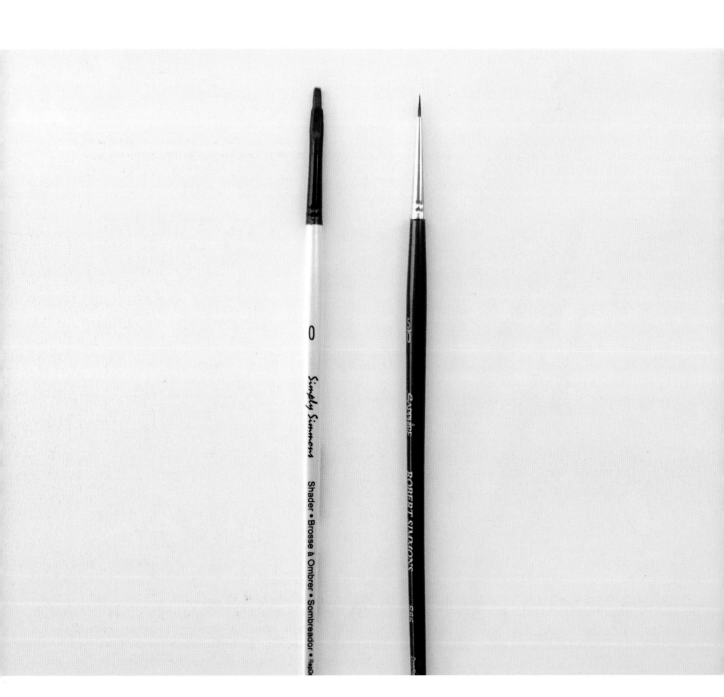

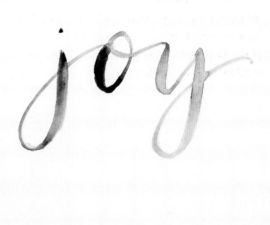

Spotter Brush

My favorite of the two is the spotter brush. It can be a little tricky to work with because it is so small; however, I've found it's the easiest for getting great contrasting thick and thin lines.

Spotter Brush Sample

Here's a sample of a word written with the spotter brush. I love how delicate and thin the lines get with this brush. It offers phenomenal contrast and enough flexibility to get some fun curves into your letters.

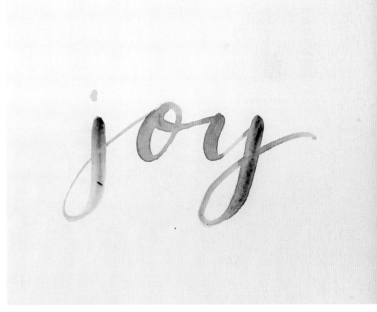

Shader Brush

This is the flat shader brush. As you can see, the tip is completely flat across, making the lines a bit more angled and dramatic. It can be a bit trickier to get contrasting lines with this brush because of the shape of the tip.

Flat Shader Brush Sample

This is an example of the same word written with the flat shader brush. You can definitely get more contrast with your lines because the brush is a little bigger; however, it takes more control to get the thin lines very thin. I've found that this brush is great for more quick script types of work than for bouncy lettering.

Mixing Watercolors

Organizing and prepping your watercolors is one of the best ways I've found to make the lettering process easier. It allows you the flexibility to move quickly and make any changes while the paint is still wet, so your letters and decorative elements will appear more consistent and clean.

At the moment, my favorite watercolors are Reeves concentrated watercolor paints. There are certainly higher quality colors out there (Dr. Ph. Martin's Concentrated WaterColors are an incredible option), but I've found Reeves to work great at beginner and intermediate levels.

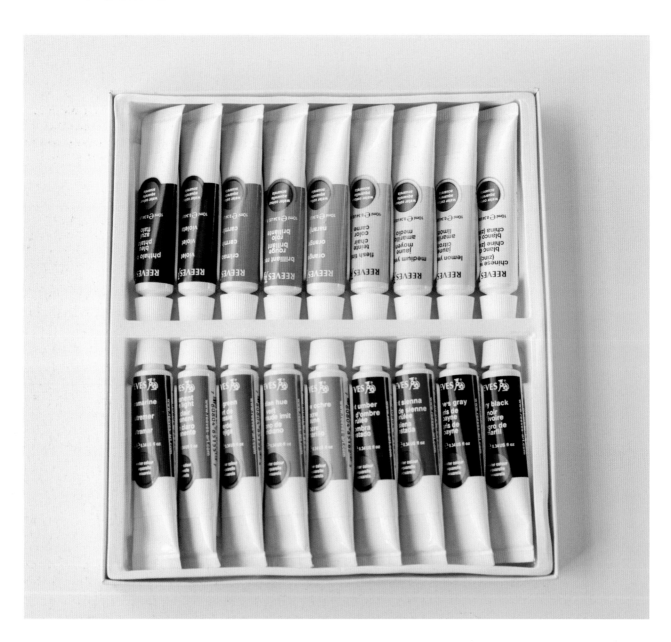

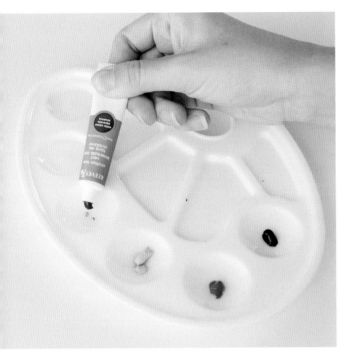

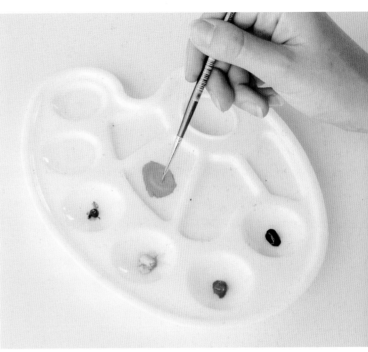

1 To prep your colors, take your watercolor palette and lightly squeeze your main colors into each section of the tray. I also fill one or two up with clean water for more transparent washes. From there, you can either add a little bit of water to dilute your colors or leave them fully concentrated.

2 To mix your color, you'll use the flat parts of your watercolor palette. Using your spotter brush, take a small portion of your desired mixing colors and blend them in the flat section of your palette. The flat surface gives you the flexibility to mix a little at a time or everything at once.

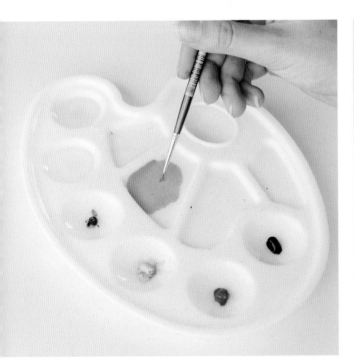

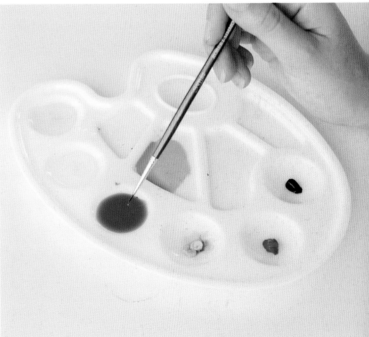

3 If you want to make your mixed color more translucent, take some clean water from your tray and blend it with your newly mixed color on the flat part of your palette. The more water you add, the more translucent it will become and the better suited it will be for creating more of a color wash than letters or decorative elements.

4 Finally, if you need a larger quantity of the same color, simply mix your colors in one of your tray sections and fill with some additional water.

Strokes

The basic starting point for all of your watercolor lettering is the stroke. The contrasting thickness of each line paired with the soft texture of watercolor is what makes this form of lettering so beautiful and timeless. Without mastering your strokes, your letters will be much more difficult to form and won't look as smooth, so this is definitely an important section that you'll want to practice!

There are two basic elements of each complete stroke: a downstroke and an upstroke. We'll begin this section by practicing each.

Note: It's okay to lift your brush! I usually need to dip my brush every push and pull sequence anyway to keep the paint color relatively consistent.

WHAT YOU NEED

concentrated watercolor
practice paper
spotter brush
water
watercolor palette

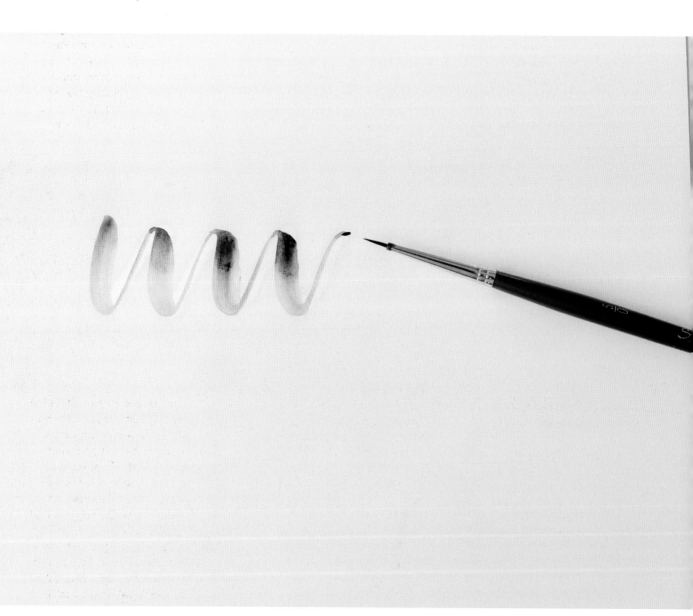

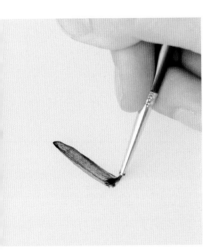

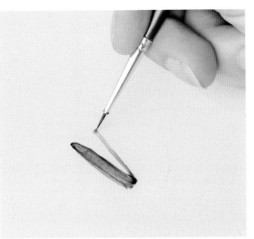

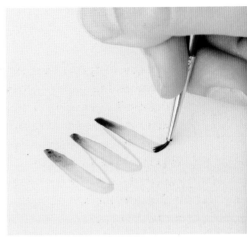

1 To form your downstroke, take your brush and dip it in your watercolor. Begin making your mark by starting at the top, and push your brush down toward the bottom of the page to create a thick stroke. As you can see in the photo, this causes the bristles on your brush to spread apart, distributing your watercolor much wider.

2 Next comes the upstroke. As you reach the bottom of your downstroke, lift your brush and lightly pull it from the bottom of the downstroke up toward the top of the page. Do you see how all of the bristles are together and barely touching the page? That creates thin lines. We call the movement that creates the contrast between strokes "push and pull" (push for your downstrokes, pull for your upstrokes).

3 Now that you know the basics of your stroke, begin practicing by forming connected Ws. This is an excellent way to practice the very basic push and pull technique. Begin by pushing your downstroke from top to bottom, then lift and pull upwards to create your upstroke. Continue this movement by forming another downstroke that attaches to your previous upstroke and repeat.

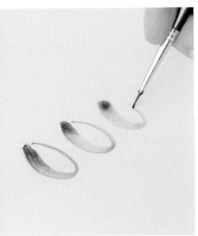

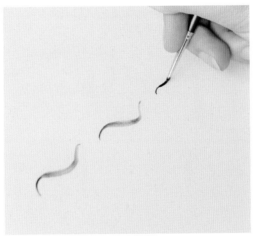

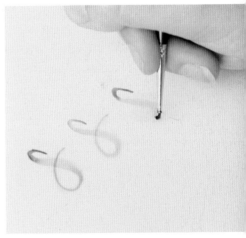

4 Once you've mastered your connected Ws, challenge yourself a little more by forming circles. These are a little trickier as you need to connect the entire stroke in one push and pull motion. Getting the hang of this will help you move on to more complicated brush maneuvers.

5 Next, try practicing a sideways stroke. This will come in handy for your letters (crossing a *t* for example) and for decorative elements. For this stroke, you'll pull up slightly, push down slightly and pull back up as you move your stroke across the page in a squiggle shape.

6 Your S shapes will probably be the most difficult to master because of the complexity of movement required. The tricky part about your S is that you need to twist your brush at the base to move from push to pull. As you push the downstroke curve to your final loop, lightly twisting your brush as you move into your pull for the loop will help make that transition a bit smoother. Once you get this, you can do just about anything!

Letters

Now that you've gotten more comfortable with your strokes, we can begin forming letters. Think of each letter as a sequence of strokes. We'll explore this technique here.

Download a free practice booklet with your lines already prepared and guide letters at jenwagner.co/practice.

WHAT YOU NEED

pencil

practice paper

spotter brush

straightedge

watercolor palette filled with some diluted paint

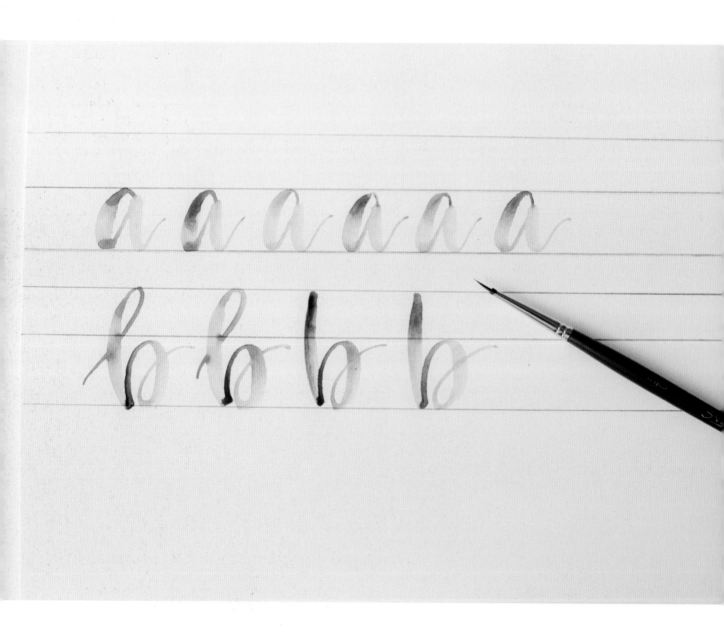

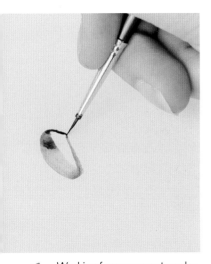
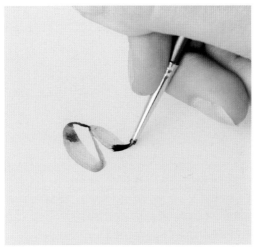

1 Working from your watercolor palette with a spotter brush, let's begin with the letter *a*. If we break it down into strokes, it becomes an oval and a line downstroke. Construct your *a* by first creating an oval to form the body.

2 Finish your letter *a* with a final downstroke connecting the end points of your oval to the final stroke. You can either finish here or lift your brush up and to the right slightly to form a tail at the end. These tails will be how we connect our letters, so it may be good to practice them now for use in the next section.

3 To begin practicing your letters more intentionally, it'll help to create your guide lines. Using a pencil and a straightedge, draw your baseline, ascender line and x-height lines. I put my x-height line right in the middle of my ascender line and baseline, but you can move it up or down further to change the look of your letters.

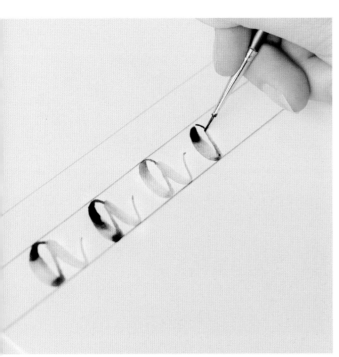
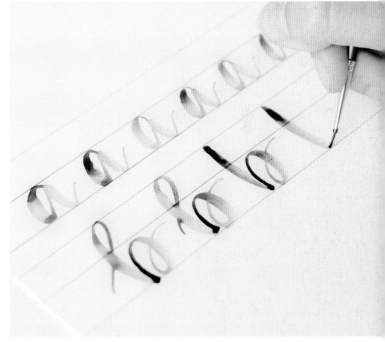

4 Begin practicing each letter across the row you just created. The repetition will help establish muscle memory and help you get an idea of what each letter feels like.

5 Continue practicing each letter down the page. This is also a great time to practice variations of each letter. You can add loops, take them away, play with tails and experiment with your lines. Refer to the letters on the following pages to help guide your practice.

Words

How you form your words is where your style will begin to show. As we discussed in our Typography section, changing your kerning, baseline, angles and other elements can take your lettering from formal to bouncy and fun. It all depends on your own unique style.

We'll now learn to connect our letters to form words and explore two different ways to connect them—with guides and without guides.

WHAT YOU NEED

pencil

practice paper

spotter brush

straightedge

watercolor palette filled with

some diluted paint

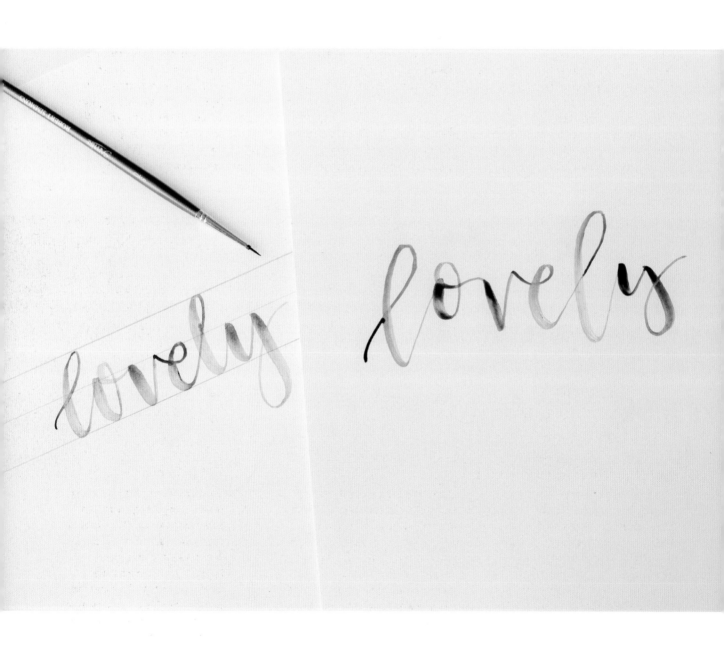

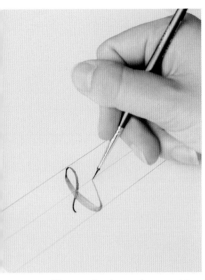

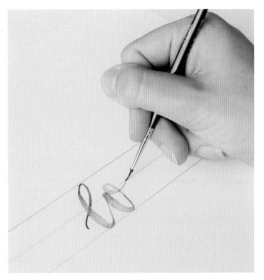

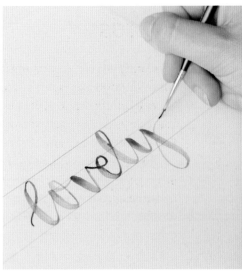

1 After you've formed your guide-lines, start your first letter. If it's an ascender, take it up to your top line and then bring it down to the baseline. From there, take your tail up to the x-height line. This is usually where I lift my brush to form my next letter.

2 Connect your next letter to the tail of your previous letter by making sure your downstroke intersects the previous letter's tail. I started my o right on top of the tail of the letter l and completed it by looping the tail around to meet the x-height line again.

3 Continue forming your word by connecting each letter to the tail of the previous letter. Some letters may take a little varying, as you can see with my ve letter sequence. Instead of giving the v a finishing tail, I gave the e a starting tail to connect them.

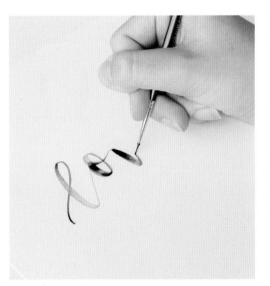

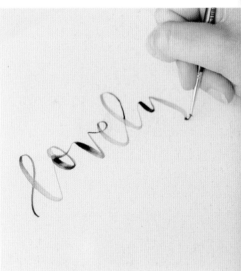

4 This time, we'll use varying baselines, ascender lines and x-height line (this is why I haven't drawn any guides). Begin by drawing your first letter and finish it with a tail. The tail can end wherever you want your second letter to start.

5 Begin connecting your letters using the tail of each previous letter. There's a lot of freedom in this technique because you can make your baseline as high or low as you want. As you can see, my o is sitting much higher than the l and slightly higher than the v. This creates a sort of bouncy movement to your words.

6 Continue forming the rest of your word by connecting the tails to each new letter. Don't be afraid to keep your baselines and ascender lines consistent—the movement is good! This technique takes a bit of practice to feel comfortable with because there's no set way to do it, so don't be afraid to practice and mess up a bit!

Phrases

Here's where all of our elements collide—creating your phrase. If you look around Pinterest, Etsy or even magazines, you'll see tons of different watercolor lettering looks and styles. Everything from your kerning and baseline to your arrangement of words and decorative elements can completely transform the style of your piece. So if your piece doesn't look exactly like mine, great! The beautiful thing about lettering is that there's no one right way to do it. So get outside your comfort zone, experiment a bit and create something beautiful that means something to you!

WHAT YOU NEED

eraser

pencil

practice paper

round brush, large

spotter brush

straightedge

watercolor palette filled with

some diluted paint

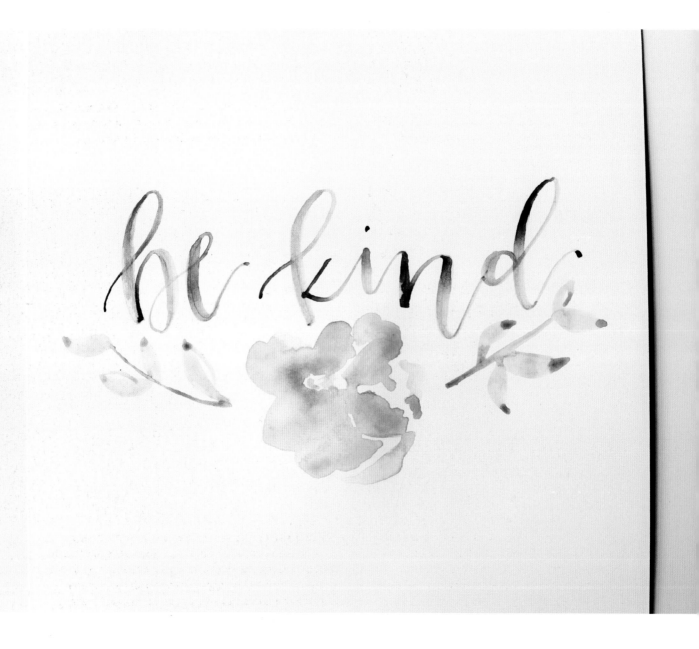

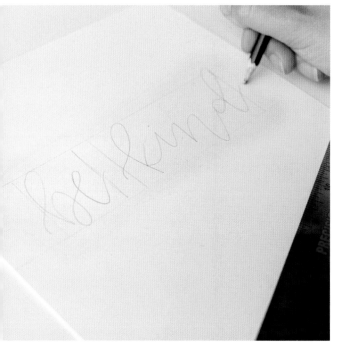

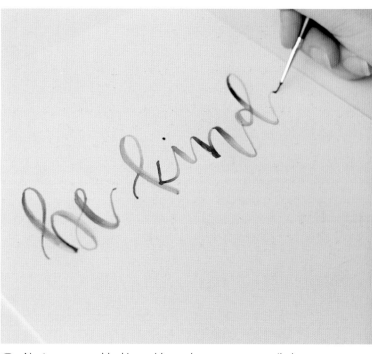

1 To create your phrase, begin by drawing guides (I used the blocking technique here) and use a pencil to very lightly draw out your phrase. Revise until it looks the way you want.

2 Next, erase your blocking guides and go over your penciled phrase in watercolor. The more translucent your color is, the more likely you'll be able to see your pencil marks.

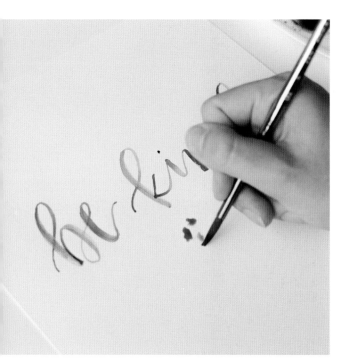

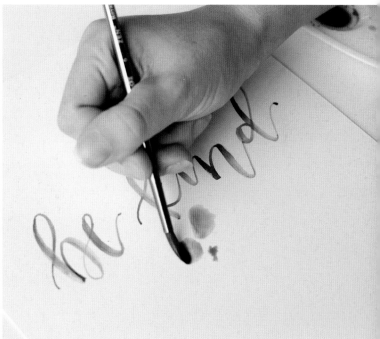

3 Begin creating your flower by placing some very wet and concentrated watercolor below your letters. You'll need to move quickly using this technique so your color doesn't dry, so adding a small amount of water to your pan of concentrated color will help.

4 After quickly rinsing your brush with clean water, sweep over your concentrated color to form your petals. Your brush should be saturated with water to create more of a wash as you pull through your concentrated color. Do this for each color spot you created and move the paint around to shape your petals the way you want them to look.

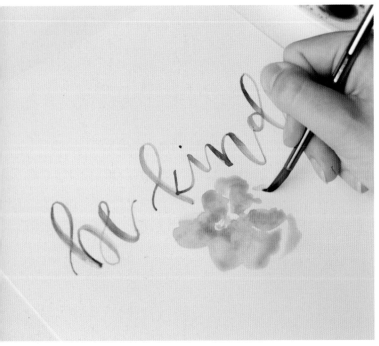

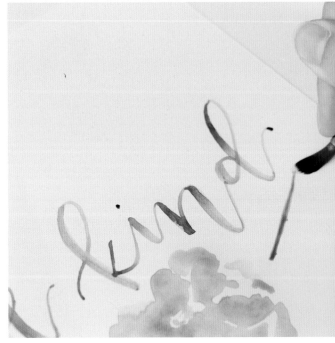

5 Continue this technique until your flower looks the way you want it to. There were some strokes where I used only the very translucent color remaining in my brush, and others where I dropped more concentrated color on my page first. The key here is to keep practicing. My flowers are something I'm still getting comfortable with, so take some time to practice and figure out what style you love.

6 Lastly, I added some simple greenery to my flower. After rinsing my brush, I created a simple curved line to form a stem using a slightly diluted green.

To form leaves, working from the stem outward, push your brush into your paper to form a small, thick oval stroke.

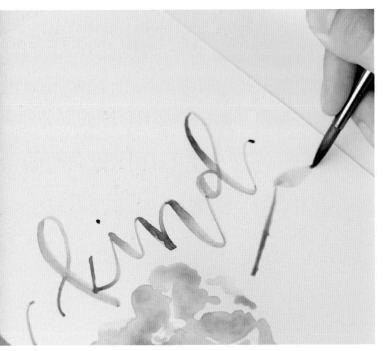

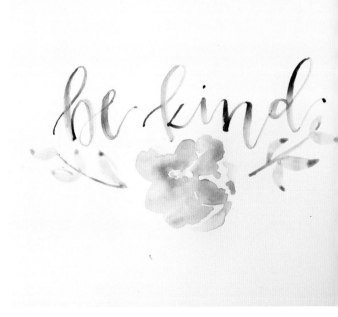

7 Then pull and lift your brush to the very tip to create a leaf shape. Continue branching leaves from your stem on both sides of your flower until you're happy with how it looks.

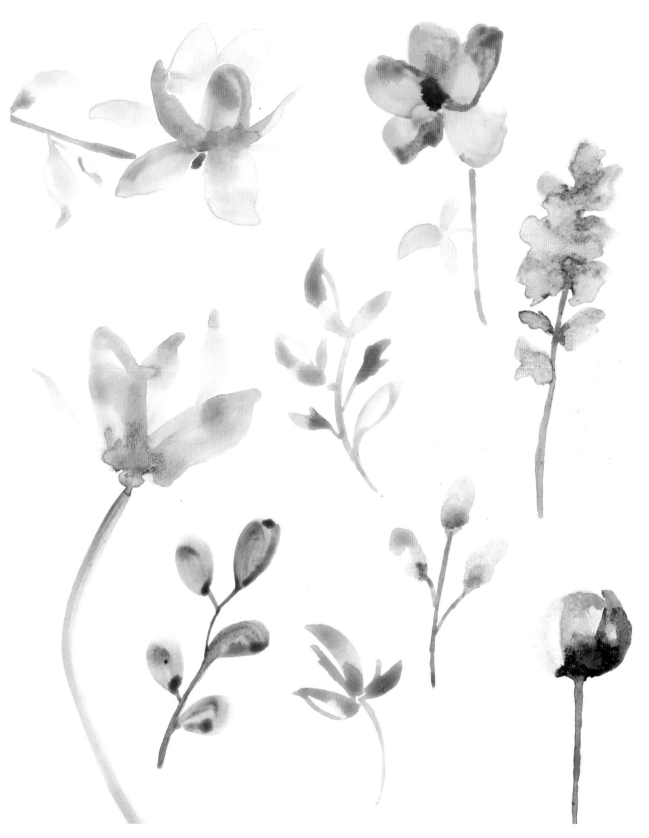

Here are some examples of floral decorative elements created using the same technique shown for the phrase we just did. Use plain water to wash over concentrated color to form petals, and add concentrated color to the petals while they're still wet to create some concentrated color bleeds. You can add flowers one at a time like in our phrase, or combine them to create a bouquet. Either way, have fun with it!

PHRASE PRACTICE

Like everything, hand lettering takes lots of practice to get comfortable with. It's really important that you stay patient and don't get frustrated with yourself! You'll continue to get better as you keep doing it, and practicing more only gives you the opportunity to give more encouraging notes away to others!

Here are a few phrases for you to refer to in your practice. Don't be afraid to experiment with layout, decorative elements, kerning and other elements of your lettering.

you are
so
loved

smile,
sunshine

ABCDEF
HIJKL
NOPQRS
UVWXY

abcdefgh
klmnopqr

tiful

Lettering with a Nib

Lettering with a nib is a challenging but versatile and very fun lettering technique! It combines old tools (calligraphy nibs) with modern calligraphy style to create an elegant and beautiful look to your letters. Let's explore this technique a bit.

The Pointed Nib and the Chisel Nib

Learning to letter with a nib can be daunting, but it's actually not as complicated as it looks. All you need for nib lettering is a nib of your choice (I prefer the Nikko G nib), a nib holder and some ink. We'll start by learning about how a nib works. They come in all shapes and sizes, and the ease of your writing can change based on which you use.

 There are two major types of nibs that I own: pointed and chiseled, and I'll introduce you to each.

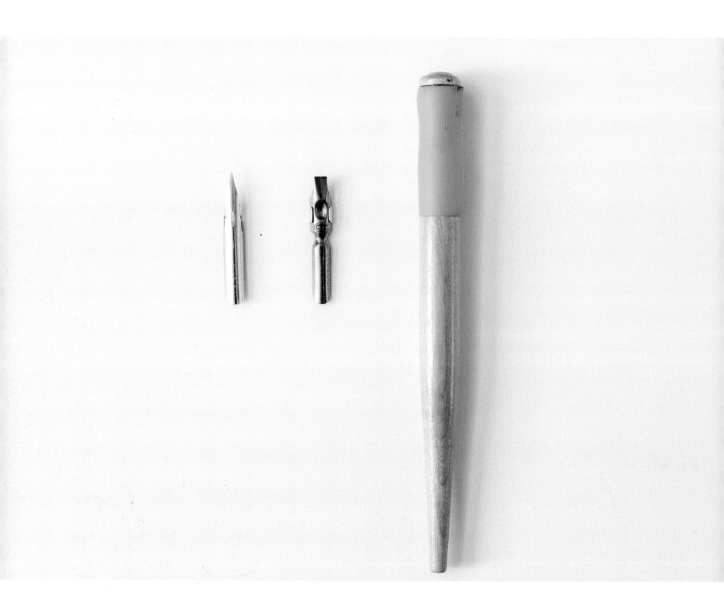

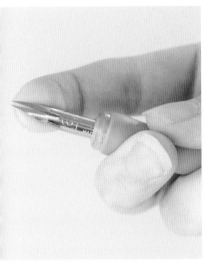

Wide Stroke
Each nib has two prongs that join together at the tip. When those prongs are put under pressure, they split and release a wider ink stroke.

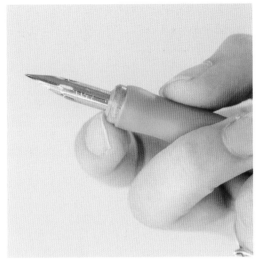

Thin Stroke
When your nib is not under pressure, the prongs come back together but still allow ink to flow, creating a thinner ink stroke.

Pointed Nib
Pointed nibs tend to give you more flexibility with your lettering as far as creating loops and pretty letters.

Pointed Nib Example
This is an example of what a pointed nib's strokes look like. Your strokes are, however, also subject to the flexibility of the prongs on your nib. I prefer using the Nikko G nib because the prongs are fairly flexible. The Zebra G nib, on the other hand, is less flexible, so the line contrast will look a bit different and is harder to create.

Chisel Nib
Above is an example of a chisel nib. These are more traditional nibs in the sense that they create more of an old-time, sometimes Gothic look.

Chisel Nib Example
This is an example of what a chisel nib stroke looks like. As you can see, the lines are very straight and clean, which speaks a bit to the inflexibility when creating more modern letters. We'll use the pointed nib for our learning.

Preparing Your Ink

Your calligraphy will only be as beautiful as your ink! Oddly enough, I've found ink to be one of the most limiting elements of nib lettering. If your ink doesn't flow smoothly, your letters won't look nearly as beautiful as they could. Thankfully, with ink being so critical, there is a vast array of ink choices available. There are seemingly endless color, opacity and finish choices out there, from opaque black to metallic gold to solid white. Even a properly mixed watercolor can create absolutely stunning results with your nib. Here, I'll demonstrate how I prep my ink for writing and share what my favorite methods are.

WHAT YOU NEED

.5 oz (15ml) ink bottle (empty)

concentrated watercolor

eyedropper

nib of your choice and nib holder

practice paper

Sumi calligraphy ink

water

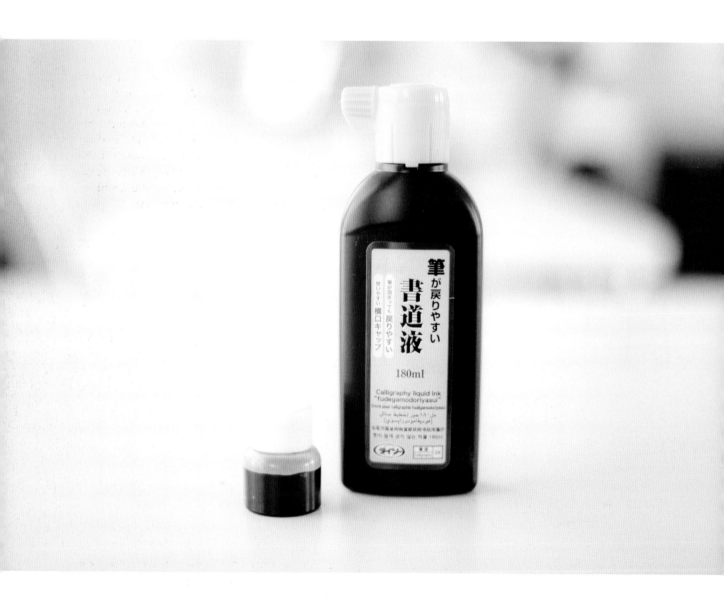

1 Start by finding your favorite type of ink! You want to find an ink that writes smoothly and has the depth of color and tone you're looking for. I chose black ink for these exercises, but ink comes in many different colors so take a look around and find the ink that's right for you!

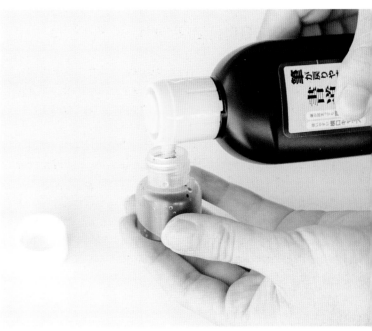

2 To prep your ink, unscrew the dispenser cap and squeeze out enough ink to fill a .5 oz (15ml) bottle about three-quarters (.75) of the way full. You want the ink to be deep enough that you are able to immerse your nib so the ink meets and fills the small opening in the center. For some inks, you may need to add water to get it to the proper consistency. If this is necessary, use an eyedropper or drips from a faucet to *slowly* add water to your ink a little at a time. Ink that is too thin is worse than ink that is too thick. Be conservative.

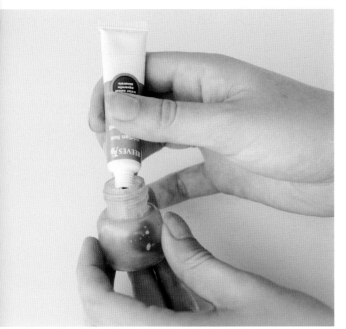

3 To prep watercolor for your nib, begin by filling your .5 oz (15ml) bottle about three-quarters (.75) of the way with fresh water. Then, mix in a condensed watercolor in your color of choice. It'll work best to use a bit more than you would for typical watercolor work because you'll need a thicker consistency.

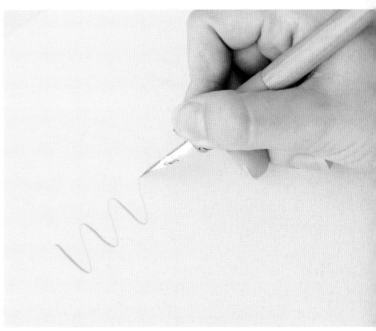

4 Watercolor creates beautiful lines with delicate color and is an excellent option if you're wanting a different color without having to buy colored ink.

Strokes

The most basic element of nib calligraphy is your stroke. The nib's ability to create high-contrast thick and thin lines helps create its unique look, and you want to work this to your advantage by practicing your strokes.

As we learned earlier, each nib has two prongs that will split when a certain amount of pressure is applied. The wider the prongs split, the thicker the stroke will appear; therefore, the more pressure you place pushing down on your nib, the thicker your stroke will be.

As you pull your nib up, the pressure releases and you can create thinner strokes. It's this contrast in pressure that leads us into our "push and pull" technique.

WHAT YOU NEED

nib of your choice and nib holder
practice paper
prepared ink of your choice

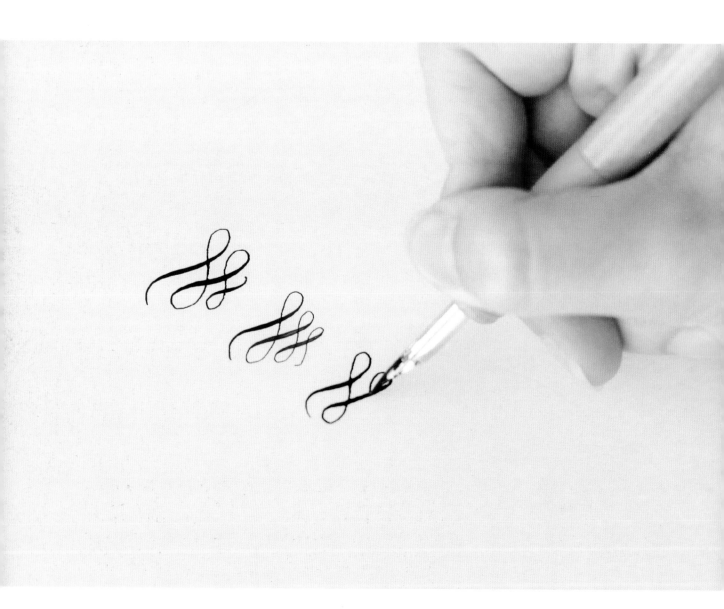

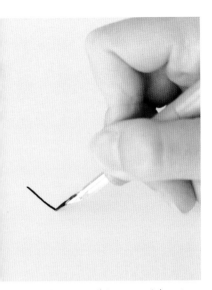

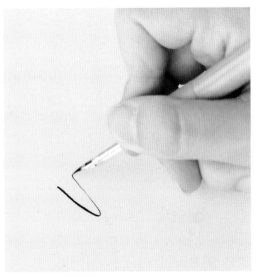

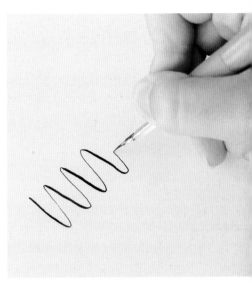

1 Dip your nib into your ink up to the small opening in the center of your nib to fill the reservoir. From here, place the tip of the nib on your paper and gently push down to open the prongs to release the ink. Move your pen down while maintaining the appropriate amount of pressure to keep the prongs open.

2 As you pull your nib back up, release the pressure to close the prongs. This will create a thinner upstroke. So you create your contrasting strokes by "pushing" the nib on your downstroke to open the prongs and "pulling" the nib on your upstroke to close them.

3 Once you get more comfortable with your upstrokes and downstrokes, begin practicing connected Ws. This will help you get a feel for connecting letters and getting the movement of your pen feeling more natural.

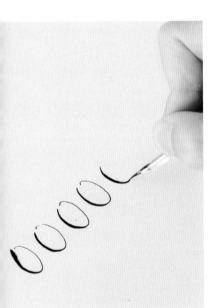

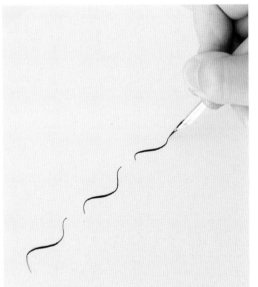

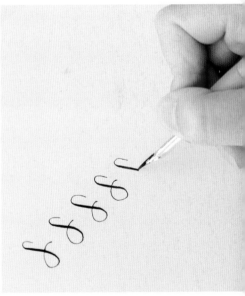

4 After you're comfortable with your connected Ws, begin forming circles, connecting a thicker downstroke to a curved and connected upstroke.

5 Next, practice your side strokes. Getting this side-to-side movement will really help your flourishes and certain lettering elements. Begin with a slight upstroke, push both across and down into your downstroke and then lift back up again.

6 Finally, work your way toward your S shapes. You'll begin with an upstroke to the left, push down from the x-height line to the baseline, and pull back up as you curve around to finish.

Letters

After you've practiced your strokes, you're ready to begin forming your letters. The same principle applies here as with watercolor lettering: It may be easier to think of your letters as combinations of simple strokes. Let's explore this a bit more.

WHAT YOU NEED

nib of your choice and nib holder

pencil

practice paper

prepared ink of your choice

straightedge

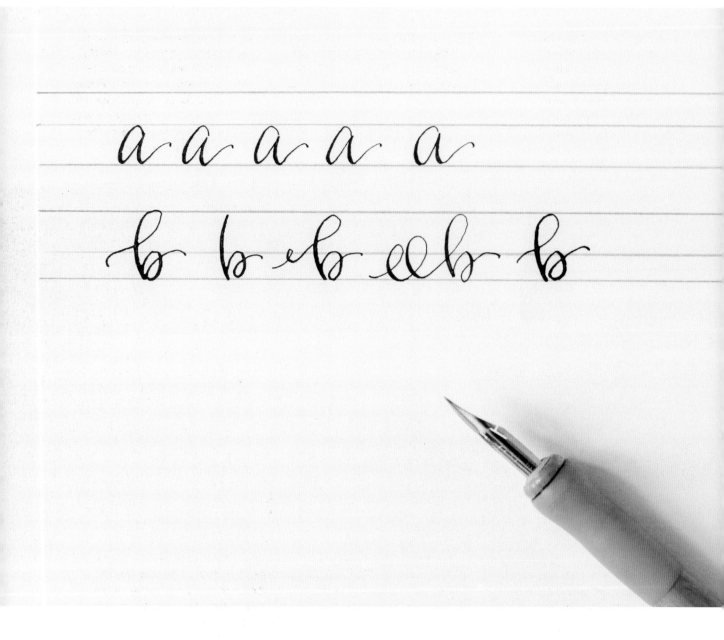

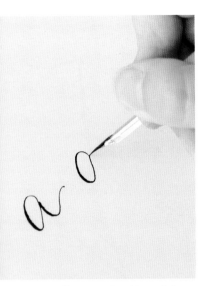

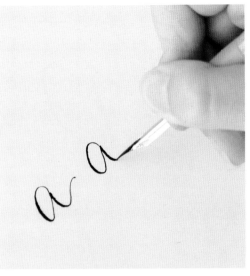

1 We'll start again with our letter *a*. Begin by drawing the oval stroke to form the body of your letter. Take a small upstroke over and to the left, push down to the baseline and pull back up to connect where you started.

2 From here, push down to create your final downstroke of your letter *a*. Pull up and curve your stroke slightly to create your tail.

3 Now, you can begin practicing your letters more intentionally. Using a straightedge and a pencil, create your guides to include your ascender line, baseline, and x-height line. These will probably be smaller than for your watercolor lettering practice.

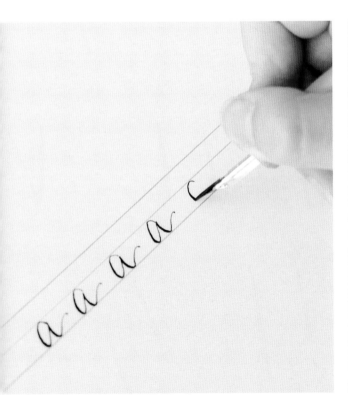

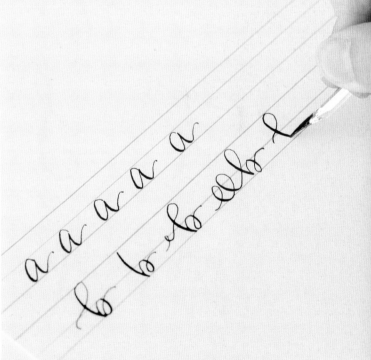

4 From *a* to *z*, begin practicing your letters across your page. Practicing one letter multiple times helps you get an idea of what the letters feel like, learn how to maneuver your pen and create muscle memory.

5 Continue practicing each letter down the page. Don't be afraid to experiment here—it's just practice! Play around with your flourishes, ascender styles and tails to develop your style a bit more. Refer to the letters on the following pages to help guide your practice.

A B C D E F

G H I J K

L M N O P

Q R S T U V

W X Y Z

a b c d e f g
h i j k l m n
o p q r s t u
v w x y z

Words

It's time to put together what we've learned and form some words! We'll go over two different ways to connect your letters: with a baseline and without a baseline. This will give you an opportunity to explore the style variation we discussed in our Typography section earlier. Let's get started!

WHAT YOU NEED

nib of your choice and nib holder

pencil

practice paper

prepared ink of your choice

straightedge

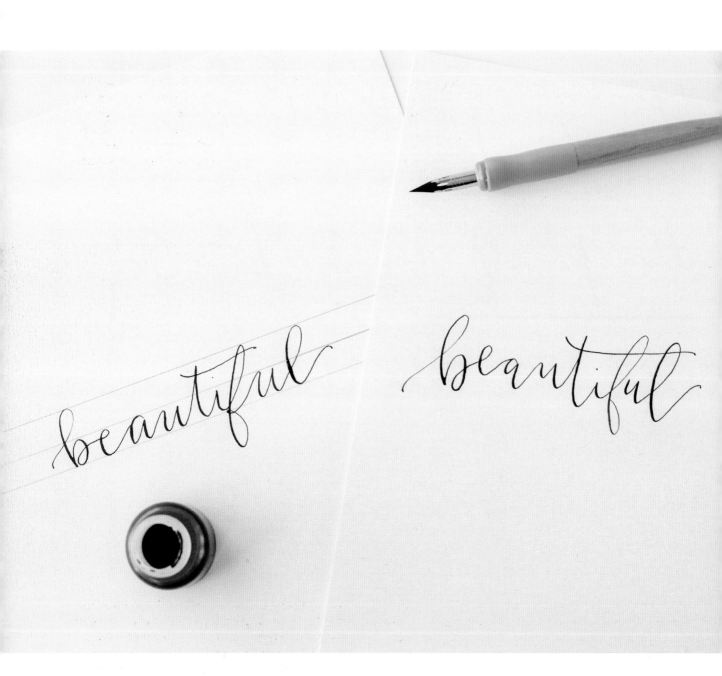

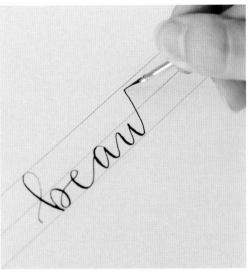

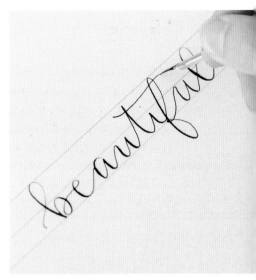

1 After you've formed your guide-lines, start your first letter. If it's an ascender, take it up to your top line and then bring it down to the baseline. From there, pull your tail just below the x-height line so the top of your next letter will meet the line properly.

2 Begin to connect your next letter via the tail of the previous letter. For the *b* to *e* sequence, I used one fluid stroke; however, for the *e* to *a* sequence, I lifted my nib after drawing the *e* tail to start my letter *a*. This way, the *a* curved downstroke would more easily connect to the *e* tail.

3 Continue connecting your letters in the same manner until you've formed your word. Sometimes you'll be able to do a few letters in a single stroke, whereas other times you'll need to lift your nib or dip for more ink.

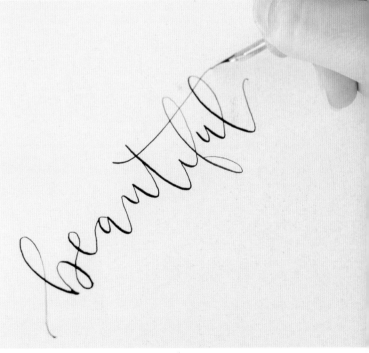

4 This time, we'll use varying baselines, ascender lines and x-height lines (this is why I haven't drawn any guides). Begin by drawing your first letter and finish it with a tail. The tail can end wherever you want your second letter to start.

5 Begin connecting your letters using the tail of each previous letter. Don't worry about it being perfect—that's the freedom of this style. Allow your baseline to vary from high to low, as well as your x-height line. If you want to keep it from getting too out of control, try keeping your ascender heights similar to create a little consistency in your word.

Phrases

It's time to put everything together and create our phrase. This is just one of a seemingly endless number of styles you can develop with a calligraphy nib. You can totally change the look of your piece by changing your ink, nib type, kerning, baseline and so much more. So don't worry so much about your piece looking exactly like what's pictured. Just have fun practicing and developing your own style as we learn to put everything together!

WHAT YOU NEED

nib of your choice and nib holder
pencil
practice paper
prepared ink of your choice
straightedge

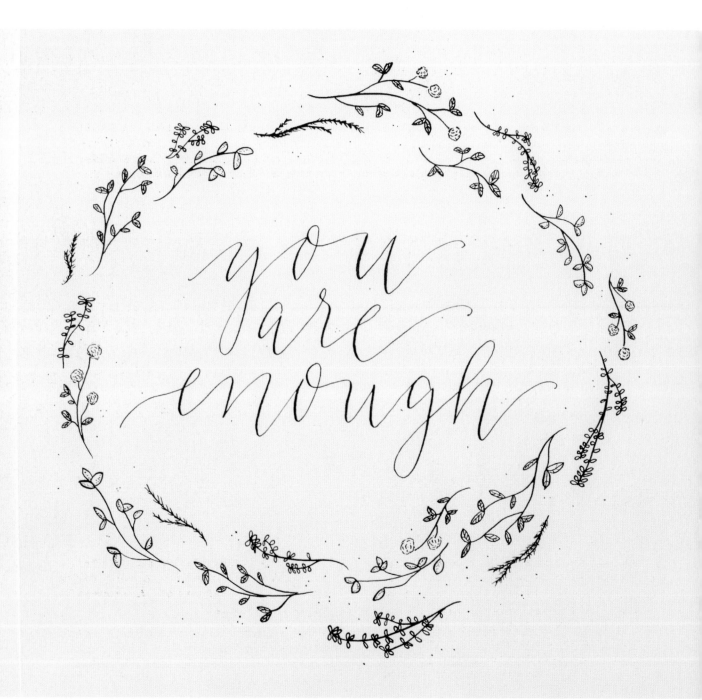

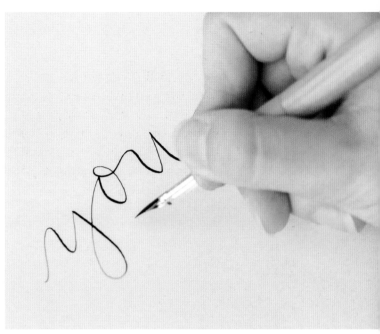

1 To create your phrase, begin by drawing guides. You can use a pencil to lightly draw out your phrase if you want, but it will be harder to cover up with a calligraphy nib than it would be with a brush or marker. Using the blocking technique could help as well to keep your wording centered.

2 Begin your phrase by writing out the first word. Keep the words that follow in mind—they may need to fit around your first word. In this case, you could choose to make the descender of the y a bit smaller or slanted to make the words beneath it easier to fit.

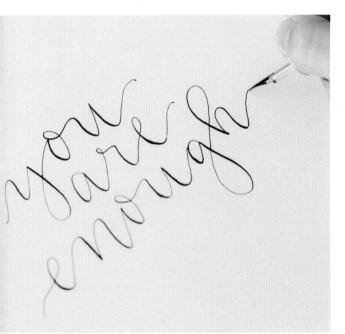

3 Continue writing out your phrase, fitting each word along the baseline of the one above by adjusting the placement accordingly. Oftentimes, I'll "air write" my word to get a feel for where my ascenders and descenders will land before writing it with ink. This usually helps me get the fitting right the first (or second!) time. When making custom pieces, I'll often use multiple pieces of practice paper trying to get the layout just right. So feel free to mess with it until it looks the way you want!

4 From here, begin forming the framework for your wreath. I do this by drawing many small branches in a circle surrounding the phrase. The main idea is to build the framework—we'll add leaves and flowers next.

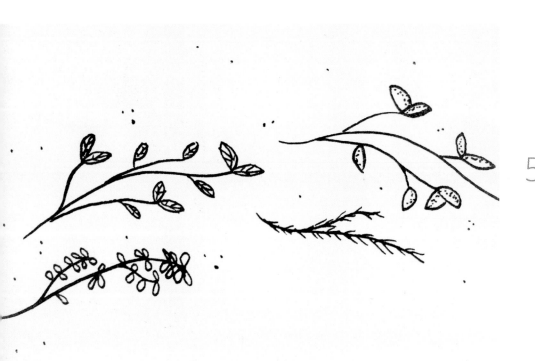

5 After you've built your wreath, begin adding a few varying types of leaves and flowers to your branches. I did five variants—the four pictured and another with small flowers. This helps create consistency while also maintaining a variety of plant types.

6 Then, alternate through each type of greenery until you've completed your wreath all the way around. I also added a bunch of small dots around the greenery to add a finishing touch to the piece.

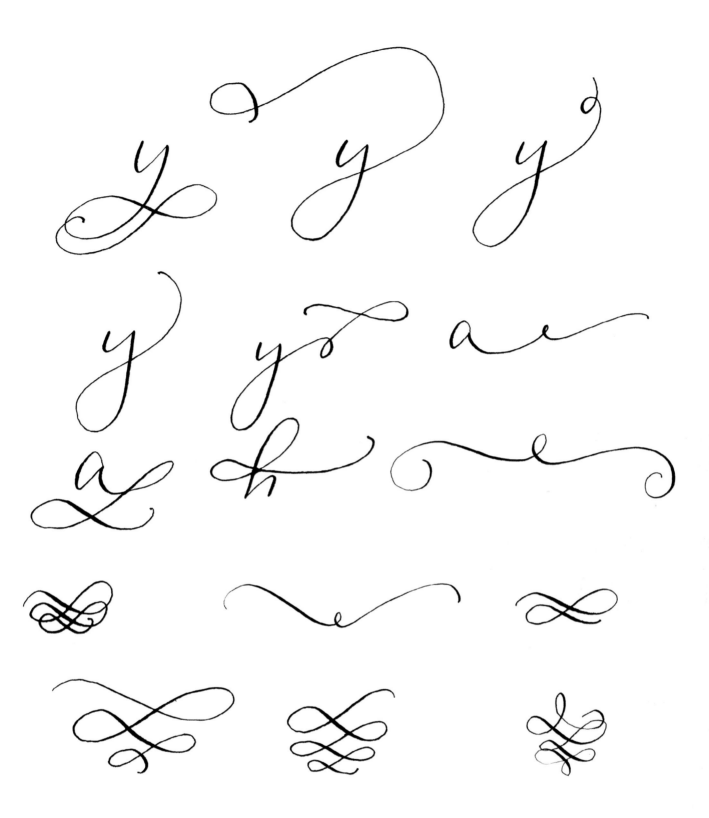

Here are some examples of flourishes you can use in your lettering in addition to the greenery we just practiced. Most flourishes can be used at the end of any letter and can be reversed if you wanted to add them to the beginning of a word. These can get tricky, so take your time, practice and go easy on yourself. The more you relax, the easier they become!

PHRASE PRACTICE

Now it's time to practice, practice, practice! Nib lettering takes quite a bit of time to get comfortable with, and flourishes may take even longer. Don't worry if you're not getting it right away. Just give yourself some more time and you'll be able to see your lettering get better and better!

These flourishes require a bit of practice. Remember, it's okay to lift your nib. In fact, the flourish from the *t* to the *h* you see here in *think* cannot be done without lifting your nib. It's an additional flourish added after the letter *t* was drawn without crossing it and stems from the *h* loop.

love you

dream big

think happy things

ABCD

ABC

Sans Serifs Practice Sheet

JENWAGNER.CO

A A A A a a a a
B B B B b b b b
C C C C c c c c
D D D D d d d d
E E E E e e e e
F F F F f f f f
G G G G g g g g
H H H H h h h h
I I I I i i i i
J J J J j j j j
K K K K k k k k
L L L L l l l l
M M M M m

Serifs Practice Sheet

JENWAGNER.CO

n n n n
o o o o
p p p p
q q q q
r r r
s s s
t t t
u u u
v v
w w
x
m

Modern Lettering

"Modern lettering" surely encompasses a lot more than what we'll cover here, but this will help give you a starting point for creating some cool letters that aren't so "feminine." Modern letters describe the standard typefaces you see on computers and in day-to-day life. Learning to work with theme adds some new value to your compositions!

Serif vs. Sans Serif

The most basic distinction between most modern fonts is whether or not the typeface has serifs. Each of these varying font types serves a unique purpose and ignites different emotions and perspectives in those who see them. One is more traditional while the other is more minimal. As you learn more about the distinction, you'll be able to see different types of serif and sans serif fonts everywhere you go—the options are seemingly endless! Let's learn a bit more about them both.

SERIF
vs.
SANS

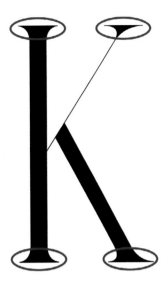

Serifs

These circled portions of the letter are called "serifs." They're the small wings and feet on the arms and legs of each letter. Each line is connected to its base with a curve, creating the special characteristic of a serif font. Slab serif fonts are similar, but they don't have the connecting curves and, as a result, they tend to be more blocky and geometric.

K A B C D

Serif Font Example

Serif fonts are generally classified as more traditional and are used in rustic, business, formal and many other settings. They often look very professional and portray an air of class and distinction that sans serif fonts don't capture as easily. So what makes them so different?

No Serifs

As you can see, sans serif letters are exactly that—sans (without) serifs. They are completely clean, typically retain the same thickness throughout and do not have any wings, feet or other lines that are not part of the letter itself. Although these font types are very different, they can be paired together to create some beautiful combinations that we'll explore next.

K A B C D

Sans Serif Font Example

Sans serif fonts are considered to be more modern and minimalistic and are used in logos, magazines, on products and in other contexts. They can be easier to read depending on the scale, so you'll see them used on many appliances, packaging and other environments where the scale of words vary.

Mixing Fonts

Crafting appropriate font combinations in your modern lettering exercises is extremely important for creating artwork that looks cohesive and makes sense. The fonts you base your letters on can make or break your artwork, so we'll explore a few simple ways to make sure your fonts work together instead of against one another!

MIXING YOUR
fonts appropriately

MIX SERIFS
WITH SANS SERIFS

Serif and Sans Serif Together
One of the easiest and most classic combinations is pairing a serif font with a sans serif font. Each is easy to read, neither detracts from the others and it looks completely timeless. A pair like this is usually a safe bet.

USE DIFFERENT WEIGHTS
within the same font family
(light, bold, italic, etc.)

Different Weights Together
Using different weights within your font family is also a great way to pair fonts. Because each letter is basically the same—only the thickness or skew is different—these font pairings will create a clean and consistent look. It is important, however, to make sure they're the same font family or else you get the result below.

AVOID COMBINING
SIMILAR FONTS

Fonts That Are Too Similar
One thing to avoid is combining similar fonts. Here, we have two serif fonts that, although they're great on their own, don't look quite right when they're paired together. To be safe, try sticking to either two contrasting fonts (serif and sans serif, sans serif and script, etc.).

keep a consistent
MOOR OR FEEL... NOT THIS
(you want your fonts to "go together")

Fonts That Are Too Inconsistent
Finally, be sure that the fonts you end up pairing share a similar feel. You want them to complement one another, not distract from one another.

Letters and Words

It's time to start practicing our letters. For these exercises, I used Baskerville Regular, Baskerville Italic and Proxima Nova Regular to form each font sheet. This is a great way to get a handle on the movement and structure of modern letters as you'll trace each font one line at a time.

Download a free practice booklet for each of these practice sheets at jenwagner.co or create your own with your font of choice!

D D *D* *D*　　*d* *d* *d* *d*

E E *E* *E*　　*e* *e* *e* *e*

F F *F* *F*　　*f* *f* *f* *f*

G G *G* *G*　　*g* *g* *g* *g*

H H *H* *H*　　*h* *h* *h* *h*

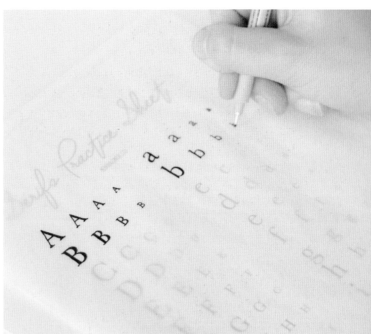

1 To prepare your paper for practice, simply tape your practice sheet down to your work surface to keep it from sliding around. Then, tape your tracing paper down on top of it. The less your papers move, the easier the exercise will be. Gather small to larger sizes of your Micron pens because you may need to switch pens as your letter sizes change.

2 Start tracing each of your serif letters, working from the largest to smallest size as you go. The point of the different sizes is to get you used to how your technique might need to change as your scale changes. Sometimes, you may need a smaller or larger pen. Other times, you may need to change your pressure or hand motion. Practicing will help you grasp how each changes and adjust your technique appropriately.

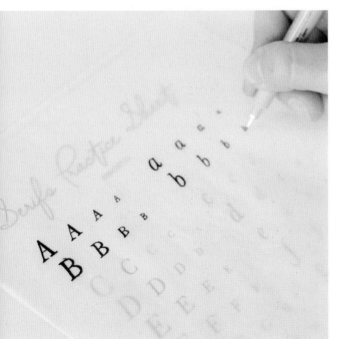

3 Next, move on to your italic serif letters. You'll notice that some of these letters aren't just slanted or skewed versions of the serif letters—some are totally different. That's because italic letters aren't meant to simply be slanted, but a variation of the font itself. Many italic serifs have small bulbs on the ends of each letter and feature fewer serifs.

4 Now, try to get a feel for how to create these letters without tracing them. Using a straightedge, create your baseline, x-height line and cap height line to begin your practice.

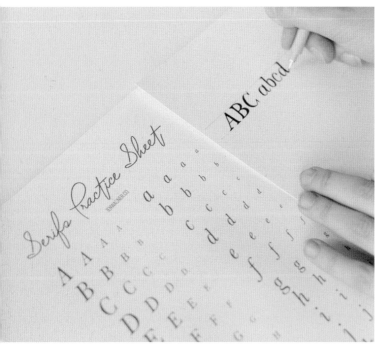

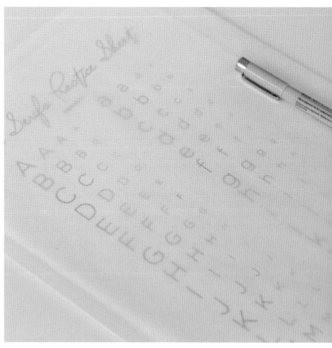

5 Next, recreate each letter—uppercase and lowercase—working from one size in all letters down to the smallest size you're comfortable with. Remember the feel of tracing each letter, how your lines move and each letter tendency, and channel it into drawing on a blank page.

6 Once you're comfortable with your serif letters, move on to practicing your sans serif letters with your tracing paper. Tape your tracing paper down to keep it from sliding around and get your marker or pen ready. I used my Micron Graphic 01 because the thicker tip makes it easier to create consistent lines.

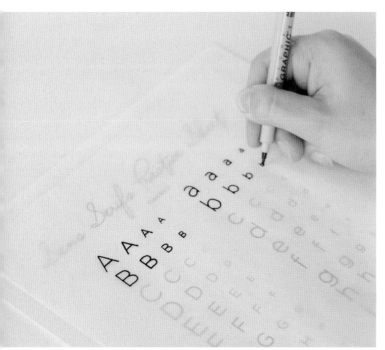

7 These letters are a bit trickier as they require a greater amount of consistency in line thickness. They also don't have a downstroke like the serif letters, so it's harder to mask any inconsistencies. Carefully trace each letter on your page, paying attention to the behavior and shape of each letter and what movements are required to replicate the look.

8 Next, venture off your tracing paper and onto a blank page. Create your guides with a straightedge like you did previously and begin recreating each letter one size at a time. Remember, this is practice—it doesn't have to be perfect!

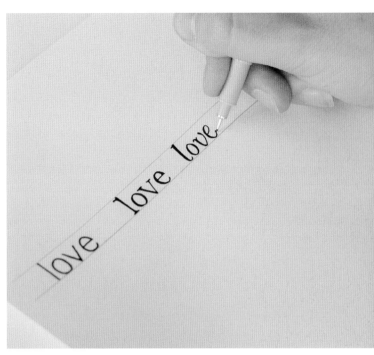

9 After some time practicing your individual letters, we'll move forward into putting it all together to create words. Using a straightedge, draw your appropriate guides to prep your page for practice.

10 Finally, begin practicing your words one style at a time. Pay close attention to your kerning and the width of each letter, making sure they are all consistent. Creating words with modern letters is very much like drawing, so sometimes it's easier to work in layers, building up your strokes and thickness as you go. Once you feel comfortable, you'll be ready to start composing phrases.

Phrases

Using modern serif and sans serif letters is one of my favorite ways to craft quotes and phrases. As we discussed earlier, there are many font combination options as well as layout options that help make each quote completely unique. You can even incorporate some cursive lettering into your piece with proper font pairing! For this step-by-step quote, however, we'll be using our all-caps sans serif letters and italic serif lowercase letters to accent our main two words. Let's get started!

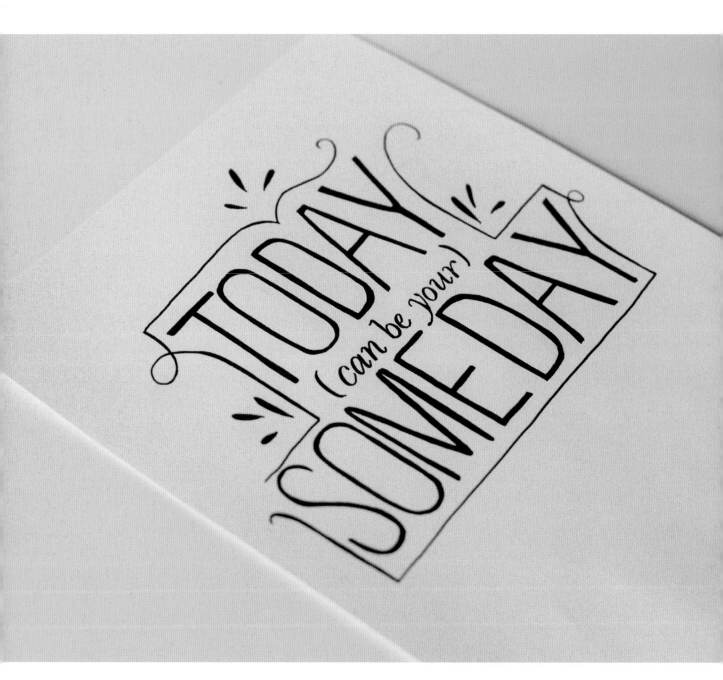

 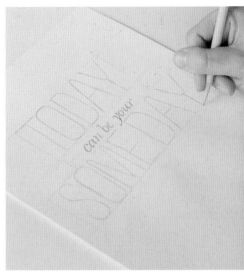

1 Using a straightedge, begin preparing your quote by drawing the baselines where you want your words to sit. I wanted *TODAY* and *SOMEDAY* to be large while keeping *can be your* smaller and sandwiched between the two words. I drew my baselines appropriately.

2 Next, use the blocking technique to lightly sketch the boundaries of your words. Knowing that *TODAY* is a shorter word than *SOMEDAY* I adjusted my blocks to fit the approximate size of each word, assuming the letters are all the same height and the kerning is consistent.

3 After you have finished blocking, lightly sketch each word into the coordinating blocks. This may require a little bit of time (and erasing!) to get right, but getting it to look the way you want will make it much easier to trace over with your pen.

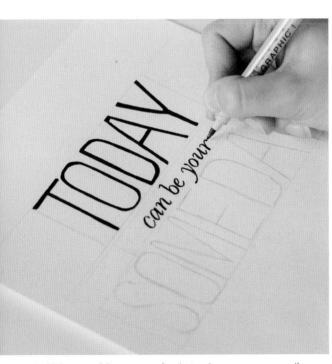 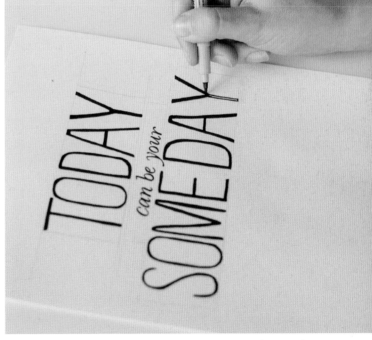

4 Using your Micron pens, begin tracing over your pencil marks to form each word. I find it easier to start with a fine pen and build up each line with larger sizes as needed.

5 After you've created your basic lines, go over each letter with a slightly broader marker, creating more consistency in your line thickness.

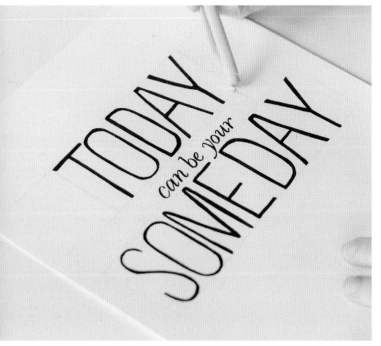

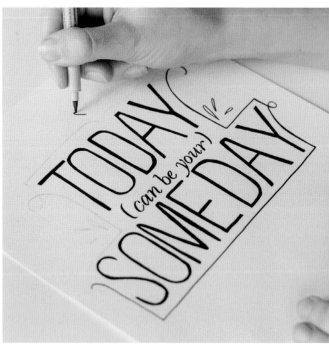

6 Now that you've finished tracing your phrase, erase your blocks and other guidelines to make room for your decorative elements. Lightly sketch your decorative elements with a pencil and revise until you are satisfied. To help make concepts easier to play with, I roughly drew a small version of the phrase on a piece of scratch paper and played with the basic shapes of each decorative element, paying attention to how they each interact with the phrase as a whole.

7 Once you're satisfied with your decorative elements, trace over your pencil marks with your Micron pens. I used the same process as my words: Start with a fine-tip pen and build your lines as you see fit. Once you've finished, erase your guides and frame. Now give away your beautiful new quote to someone in need of encouragment.

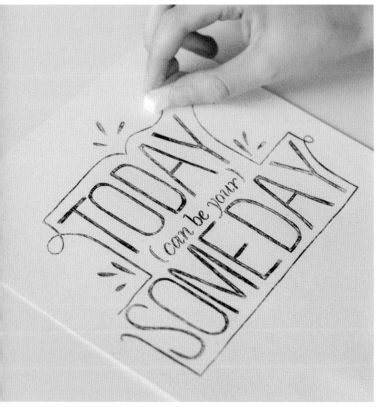

8 (Optional) If you'd like to add a bit of texture to your quote, using this technique to create texture is really easy and produces great results! Simply take a piece of chalk in the same or similar color as your paper and, using the broad edge, run the chalk over the entirety of your quote. Work from top to bottom, left to right. If your chalk is a slightly different color than your paper, run the chalk over the entire page to create a consistent look and feel.

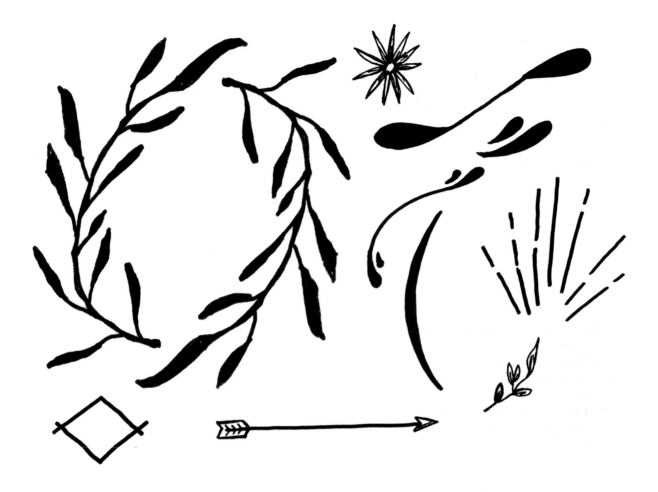

I've found the best way to discover new decorative elements for modern lettering is to study what your heroes are doing, so hop on Pinterest and take a look at what elements others are using to help inspire your own practice. Many quotes include simple tapered or curved lines underneath emphasis words, or swashes surrounding certain words or phrases to make them pop. I've included a few elements here for you to reference before you start exploring on your own.

PHRASE PRACTICE

Learning how to compose different phrases with modern lettering can be really tricky. It is very helpful to use blocking techniques to shape your phrases more easily and accurately. Don't be afraid to use even angled guidelines and blocks (see Work Hard & Be Kind) to give your phrase form and structure.

Here are a few phrases to help guide your practice. Remember to be patient, give yourself some grace and remember that this is just practice!

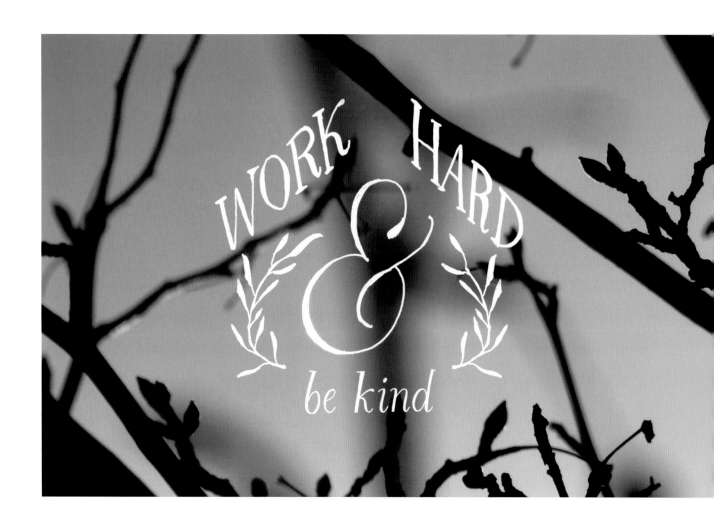

BE THE *change*

[HAP]
[: PY]

Editing

As you get more comfortable with your lettering, you may see some slight changes you wish you made after your piece is already done. There may also be a few more simple changes you'd like to make, such as smoothing out your lines and making digitizing easier. This is where editing comes in! We'll learn the simplest way to fine-tune your piece before we move on to digitizing it (where you can edit even more!).

WHAT YOU NEED

Micron pens (variety of sizes)
original art (to be edited)
tape
tracing paper

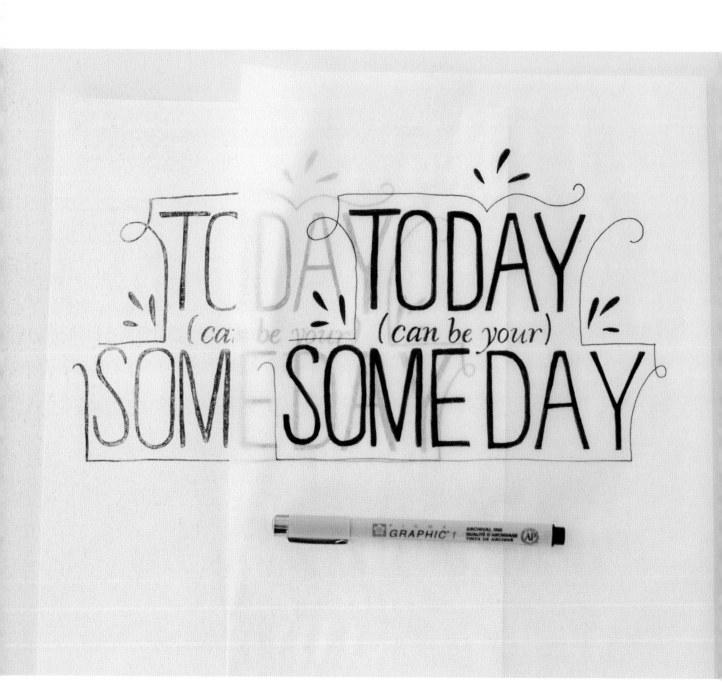

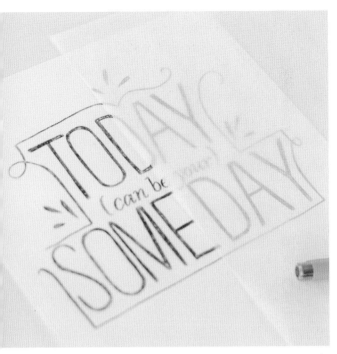

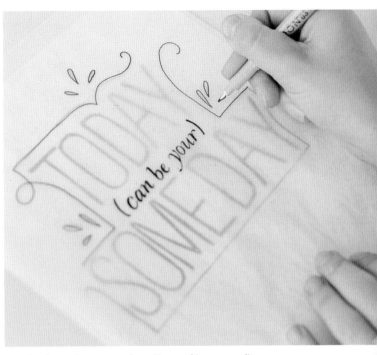

1 To begin editing your phrase, get your artwork ready to work with. If you don't wish to work directly on your original, tape a sheet of tracing paper on top of your work. The tape will keep the tracing paper from sliding around.

2 Begin tracing over each section, making your edits as you go. When I edit, it's easiest for me to do similar things in groups. I started with my italic serif font, moved on to my decorative elements, then began working on my main letters, letting everything dry in between.

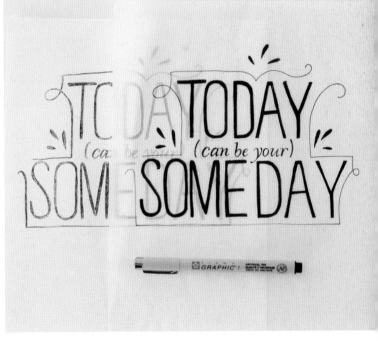

3 Finally, form and fill your strokes, creating a consistent thickness from letter to letter. To make it easier for me to make the thickness of each letter similar, I outlined each letter then filled them back in. Once every letter is filled and looks good, you're ready to digitize your phrase!

Digitizing

Once your piece looks the way you want it, we're ready to move on to digitizing your work. Digitizing is essential for placing your phrase on different backgrounds, making it really large or even preparing it for print. The process can seem daunting, but it's relatively simple once you practice it a bit. Let's digitize our phrase!

WHAT YOU NEED

Adobe® Illustrator® software

Adobe® Photoshop® software

camera or scanner

computer

image of your edited artwork

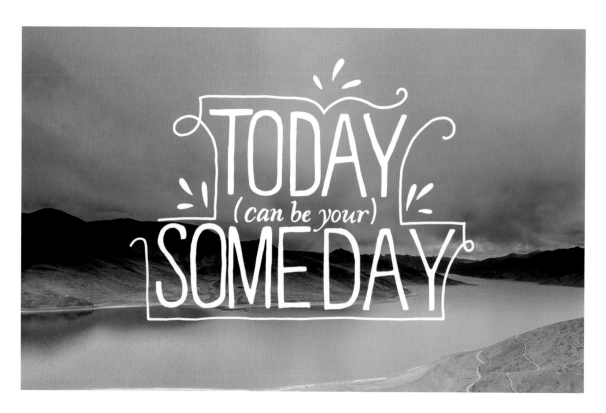

1 To begin digitizing your artwork, either take a photograph (natural light works best, avoiding shadows) or scan your piece to your computer. It's best to take your photo from directly overhead, making sure there is as little distortion as possible. As you can see in this photo, taking the picture from an angle makes your piece look very different! Once your photo is taken, upload it to your computer. From here, we'll open up our new image using Adobe Photoshop.

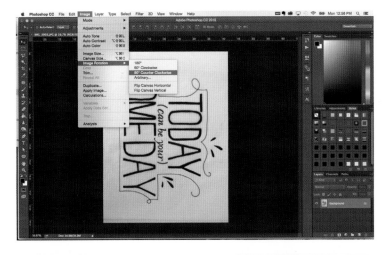

2 Once your image is open in Photoshop, rotate it if necessary to be the correct side up. You access this capability by going to Image > Image Rotation. Select the appropriate option from the menu to rotate your canvas right-side up.

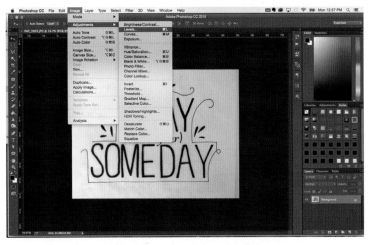

3 Next, desaturate your image through the menu options Image > Adjustments > Desaturate. This converts your image to black and white, which makes it easier to separate your text from your white background.

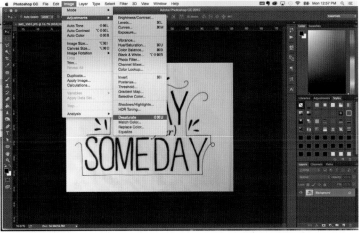

4 Then, use the Levels adjustment to make your background completely white, helping it stand out from your text. To access this tool, click Image > Adjustments > Levels.

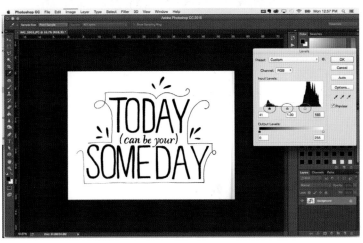

5 In your Levels window, move the sliders left or right until your background is completely white and your text is completely dark. The slider on the far right adjusts highlights, so moving it to the left will make your whites brighter. The far left slider adjusts shadows, so moving it to the left will make your blacks darker. Finally, the middle slider adjusts your midtones and is excellent for fine-tuning your image in either direction. **If you don't have access to Illustrator, you can stop here. If you'd like to place your lettering on top of an image, copy and paste your work into another document on top of your desired image. To get rid of the white background, set the layer style to "Multiply." If you want white text, invert your image (Image > Adjustments > Invert) and set the layer style to "Screen" to get rid of the black background.**

6 Once you've adjusted your Levels appropriately, copy and paste your image into Adobe Illustrator. From here, click on the arrow next to the Image Trace button and select Silhouettes from the menu. This will create a vector tracing of just your text without a white background.

7 After the Trace action is complete, open the Image Trace Panel to gain access to further adjustment options.

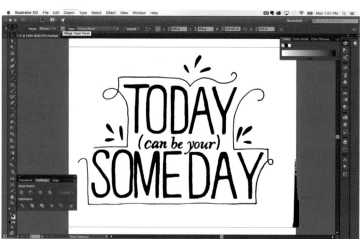

8 For this image, my original Live Trace made my lines a little bit choppy. To smooth them out, I slid the Threshold slider in the Image Trace Panel slightly to the left. This asks the program to trace in a little less detail, smoothing the lines.

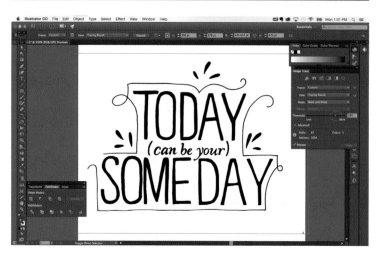

9 Next, click the Expand button to create individual shapes out of your image. Without the Expand button, your image (although it's still a vector) remains one solid piece, so moving individual elements is impossible before expanding.

10 Once you've expanded your object, click Object > Ungroup to make each element movable on its own. Sometimes you need to click Ungroup more than once.

11 Begin adjusting each individual element as needed. If something was a little off-center on paper, adjust it here.

12 Thanks to the Expand tool, I thickened my decorative outline by selecting it and adding a stroke in the toolbar. If you need to do this too, make sure your stroke is the same color as the object you're adjusting.

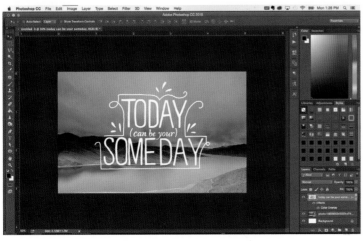

13 Finally, copy your artwork from Illustrator and paste it back into Photoshop on top of an image of your choice. Then, adjust your color by adding a Color Overlay using your Layer Style options (accessible via the half-colored circle button at the bottom center of the Layers panel or by double-clicking on the layer you'd like to adjust).

thank you!

Lettering Projects

Now that you're more comfortable with
lettering basics, we're ready to dive into
creating projects! These are designed to be
shareable, so share your work as gifts for
friends, family—even strangers—as you
continue to practice. The ideas here can also
add an air of fun to your own home.

Aaron Wagner
1234 N. MAIN ST.
denver, co
80123

Envelope

As a kid, getting mail was one of the most exciting parts of the holiday season. To see your name written in Grandma's beautiful cursive on your favorite color envelope, just itching to find out what was hidden inside. That excitement doesn't have to end as an adult! For this project, we'll learn how to beautifully letter an envelope so you can ignite some cheer in your family and friends from afar.

WHAT YOU NEED

envelope, dark color
eraser
gel pen, white
pencil
straightedge

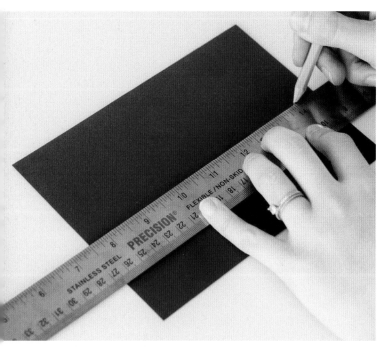

1 To begin addressing your envelope, lightly draw three lines where your address will go. Space them apart equally to create some consistency in your size. You can add an ascender line above each baseline to help create even more consistency—totaling six lines.

2 Now, pencil out the name of your recipient. For this envelope, I chose a varying baseline and used my capital letters to create some visual interest by creating some small swashes with the A-cross and the last upper curve of the W (you can see this better in subsequent photos).

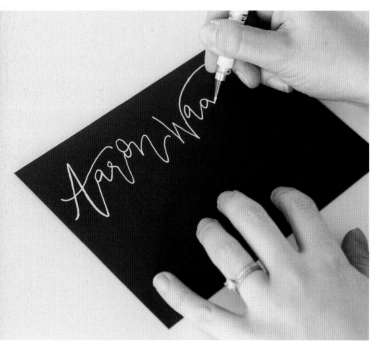

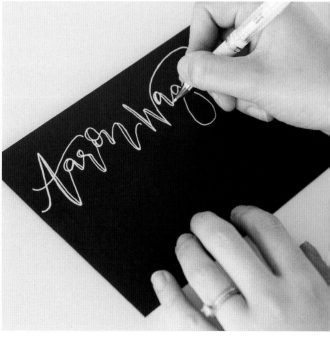

3 Once you perfect the recipient's name in pencil, take your gel pen and write over the penciled line. Don't worry too much if your lines are shaky or don't cover the pencil entirely; we can fix that in our next step!

4 Using your pen, begin to form your downstrokes. Draw a line adjacent to each downstroke, creating a bit of space between each line. Make sure they mimic the curves and feel of each original line they are drawn next to and ensure they connect at the top and bottom.

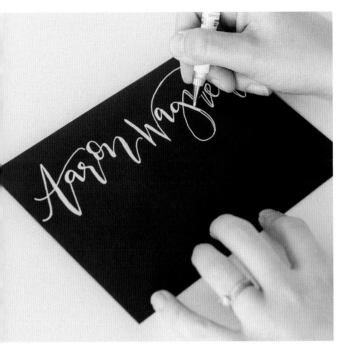

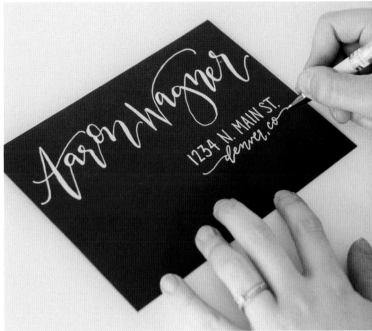

5 With a pen in either the same or a new color, fill each downstroke so it is completely solid in color. Filling your downstroke with a different opaque color will add a bit of flair and fun to the name, but make sure you color inside the lines for the desired effect.

6 Now that you've finished writing your recipient's name, write his address using the guidelines you created. After you write your street address, write the city and state below in cursive. To help keep your address looking centered, add tails to the beginning and end of each city/state combination if it looks a little off-center. The tails may be different lengths, but it still helps it look more centered.

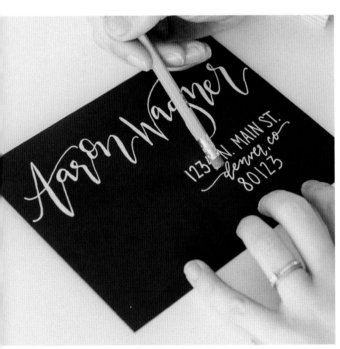

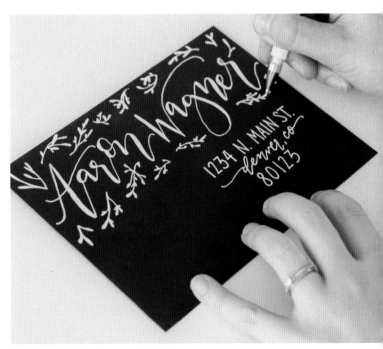

7 Using your eraser, lightly remove the guidelines you used for the name and address. Depending on the pen you use, erasing may cause damage to your ink, so be careful in this step!

8 Finally, add some decorative elements to your envelope. I chose the florals we went over in the Modern Lettering section, but you can choose whatever goes best with the feel of your envelope.

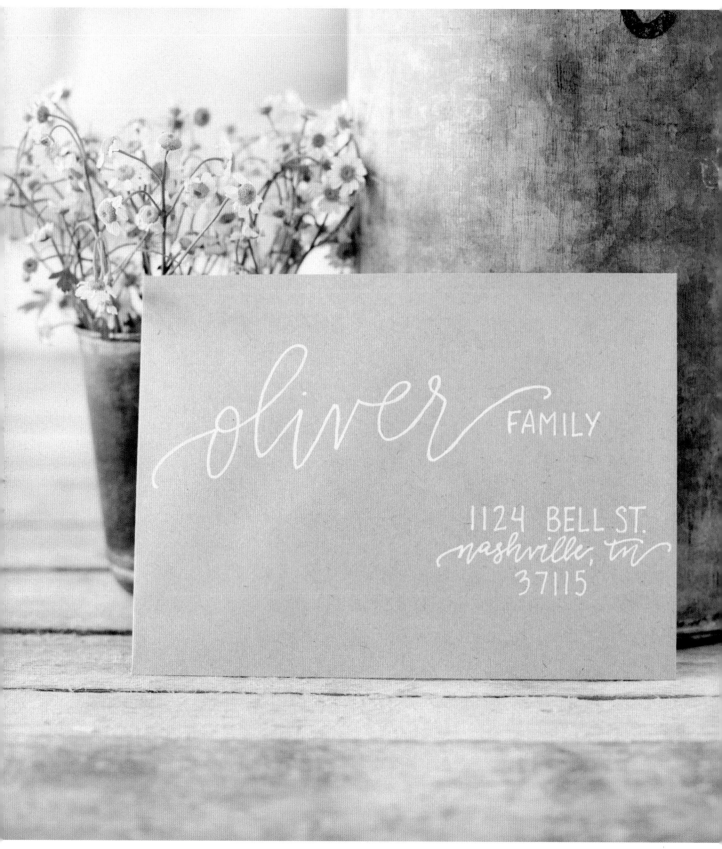

Here's a quick variation of our envelope project. For this version, you don't even need to thicken your downstrokes. Use a varying baseline to help your last name climb up the envelope slightly on its way across, and use an all-capital letter print for your "FAMILY," "MR. + MRS.," street address and other contrasting elements. This is definitely one of the most simple envelope formats I do, but it's very elegant and beautiful in its simplicity!

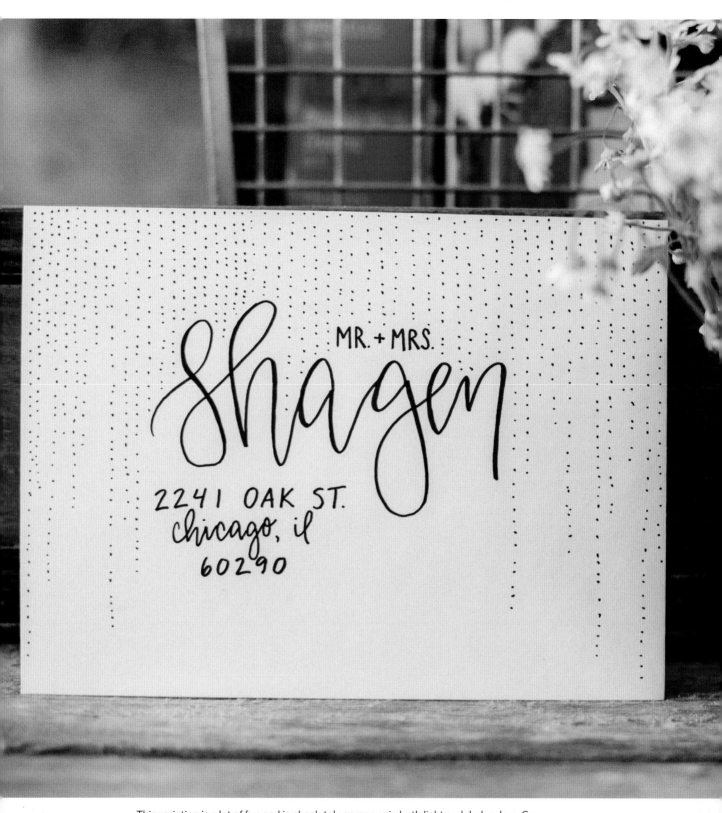

MR. + MRS.

shagen

2241 OAK ST.
chicago, il
60290

This variation is a lot of fun and is absolutely gorgeous in both light and dark colors. Can you imagine that "glitter rain" in gold on a black envelope? Heavenly. For this format, I wrote out the name and address before I began my dots. Working from the top of your envelope to random points varying from a third (.33) of the way down to the very bottom, lightly create dots in a straight line. Once you get across to your name and address, stop your dots slightly above your lettering. This will create a "fall around" effect that makes it look like the dots are being stopped by the letters.

MENU

cheeses

— SMOKED GOUDA —
— BAKED BRIE —
— CHIPOTLE GOAT —

breads

— HERBED FOCACCIA —
— ROSEMARY SOURDOUGH —
— FRENCH BREAD —

wine

— CABERNET —
— MERLOT —
— CHARDONNAY —

Butcher Paper Menu

In our home, we absolutely love having friends over for dinner! Every week, we have a family dinner at our house where the goal is to make others feel loved and welcome.

Decorative elements like a butcher paper menu can easily add an extra handmade touch to whatever event you're hosting, making your guests feel that much more special!

WHAT YOU NEED

butcher paper or kraft paper roll
 (and roll holder)
pencil and eraser
permanent marker, black
straightedge (optional)

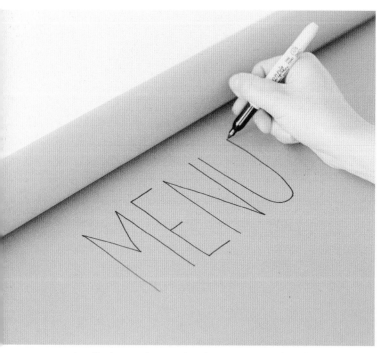

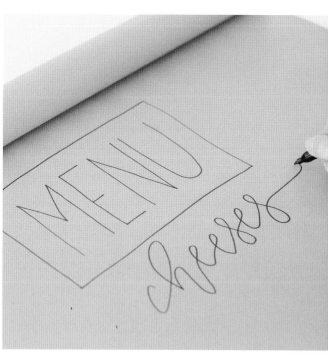

1 Begin creating your butcher paper menu by rolling out your butcher paper to the length you plan to use. Then, create your title "MENU" (or whatever title you desire) on the top in simple, tall sans serif letters. You can enclose the title with a box or other decorative element if you like.

2 Next, write out your section headings in cursive lettering, trying to center it to the best of your ability. I used a varying baseline and standard kerning for my headings.

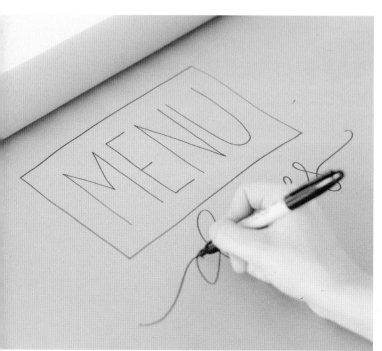

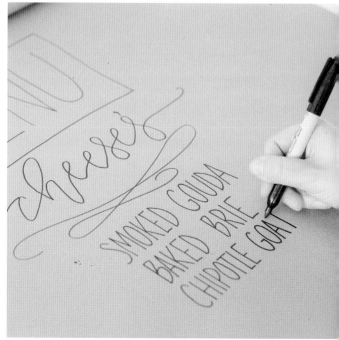

3 If you're finding it tricky to center your headings, try creating the illusion of it being centered using your tails. Creating tails on each side of your word that begins and ends in a way that frames the word will help center it. So if your word is a little too far to the right, create a tail at the beginning of the word that is a little bit longer to help visually move the word over to the left.

4 Next, begin listing your menu items in all capital, narrow sans serif letters. Lightly create guides with a straightedge if you need help keeping your words straight on the page. You can also use the blocking technique to guarantee each item will be centered. Then lightly erase your guides after you've finished using them.

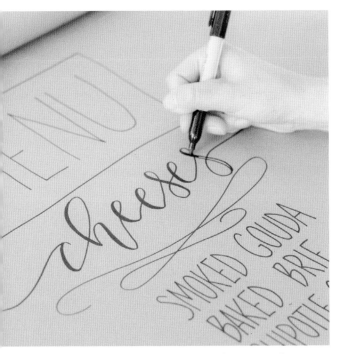

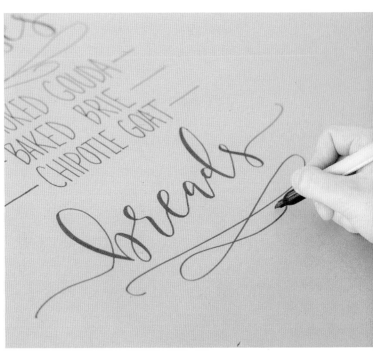

5 Now, we'll finish each of our headings by creating down-strokes for each letter. Using techniques explored earlier, create larger downstrokes and fill each with your marker.

6 Add decorative elements to each heading as you like. I chose to use the underline swirls we learned to do in the Lettering with a Nib section.

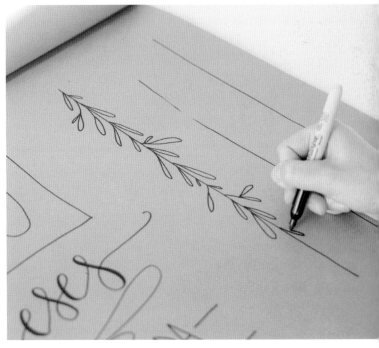

7 Once your menu is complete, begin adding decorative elements to each side of your menu. To create the olive branches for this menu, draw three lines on each side of the menu in various lengths.

8 Then, use your marker to create leaves going down each branch, from top to bottom. Don't be afraid to use different sizes and angles to make it look more natural.

 Once you've finished your decorative elements, either cut your menu from the roll or mount the roll on a wall to display your beautiful menu to the world!

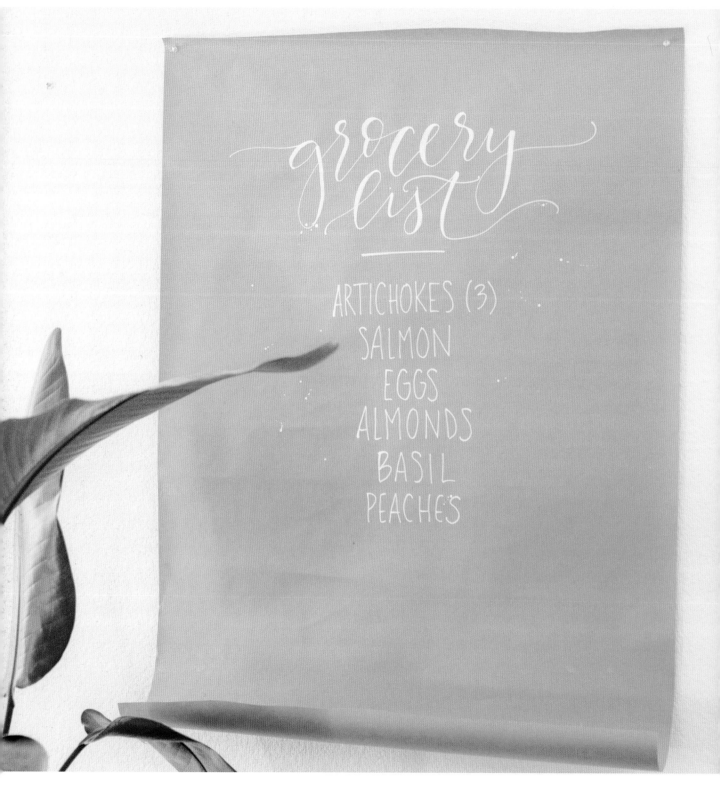

grocery list

ARTICHOKES (3)
SALMON
EGGS
ALMONDS
BASIL
PEACHES

Butcher paper isn't just for menus. Use yours to create grocery lists, welcome signs, seating arrangements and more! For this variation, I used a chalk marker and spattered the ink a bit to give it some texture. (You can do this by creating a quick motion from about a foot above your paper and quickly stop a few inches where you want the paint to spatter. Make sure your marker is primed.

You can use a white paint marker, but I've found them to be far less opaque than chalk markers as they require you to go over the text several times to get a bright white.

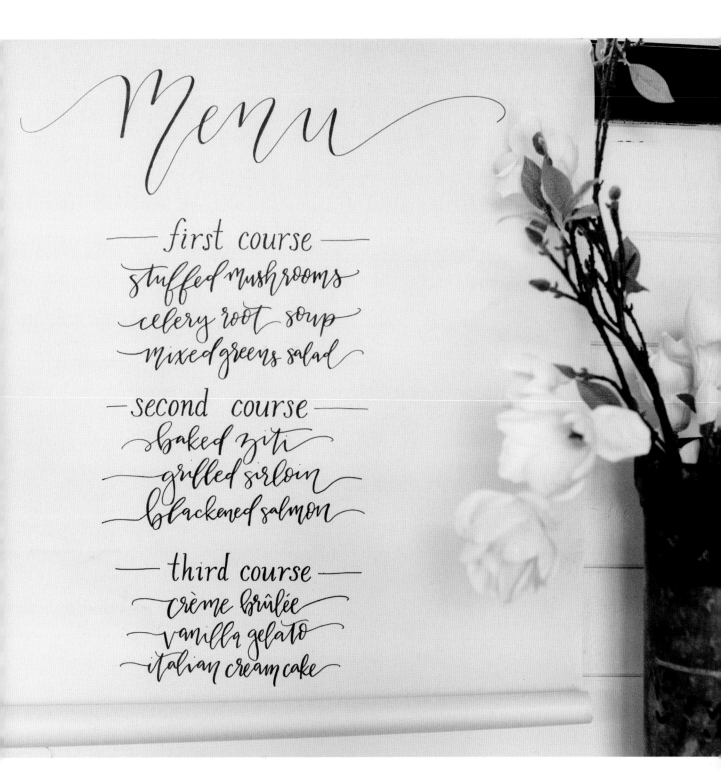

Menu

— first course —
stuffed mushrooms
celery root soup
mixed greens salad

— second course —
baked ziti
grilled sirloin
blackened salmon

— third course —
crème brûlée
vanilla gelato
italian cream cake

Butcher paper is a really flexible medium that comes in a few different colors to suit different occasions. For this classic white menu variation, I combined cursive lettering and lowercase italic serifs to create an elegant and minimalistic menu.

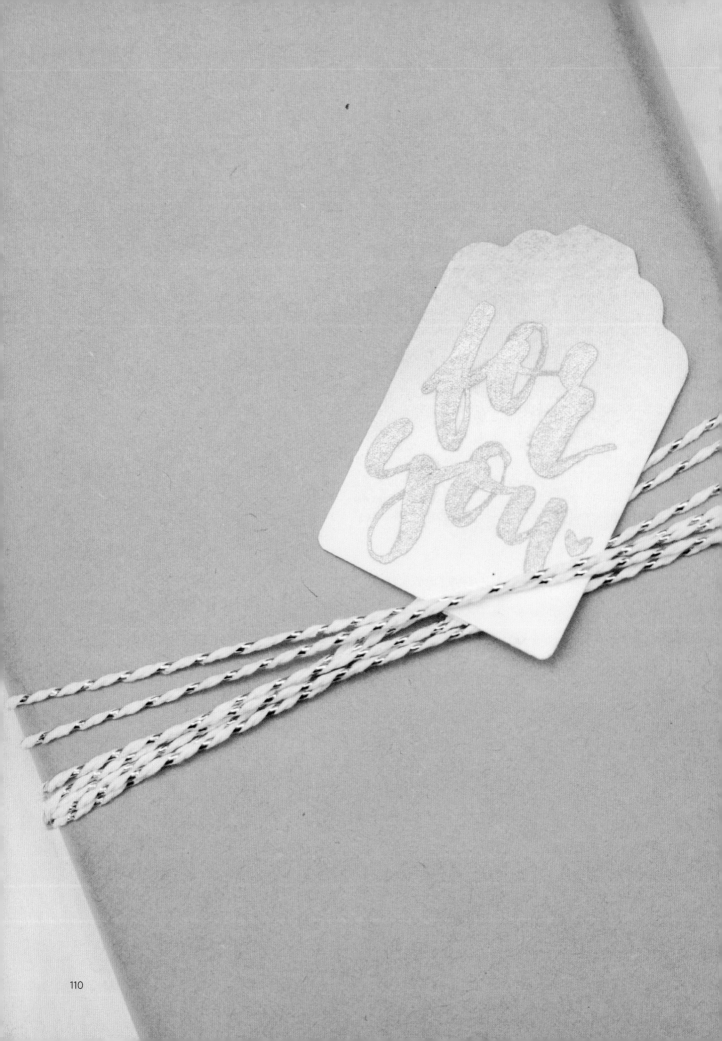

Gift Tag

There's something about giving gifts that's equally as thrilling for the giver as it is for the recipient. The thoughtfulness that goes into giving a great gift shows how well you know and pay attention to the recipient, and it can be so much fun to surprise them! I pay really close attention to small comments my husband makes throughout the year to make gifts for special events a cinch—and a great surprise to him! In this section, we'll create special gift tags to make your wrapping that much more thoughtful.

WHAT YOU NEED

liner brush

liquid metallic leaf

scissors (optional)

tag punch

watercolor, color of your choice

watercolor brush (and cup of water)

watercolor paper

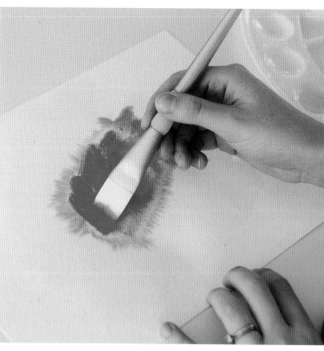

1 To begin creating your watercolor effect, take some clean water and create what's called a "wash" on your paper. You can do this by simply brushing a large amount of clean water over your paper. This provides a base for your color to bleed and expand.

2 Now, add some concentrated color to the center of your wash. Begin working from the center outward to help your color spread through your wash.

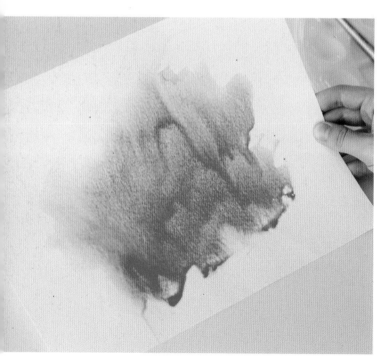

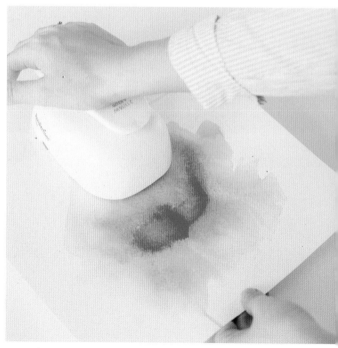

3 Next, tilt your page to help encourage your color to run farther through your wash. You can turn your page top to bottom, left to right, any direction you want your color to run. Then, set it down to dry.

4 After your page has dried, use your tag cutter (or a pair of scissors) to cut your tag shapes out of your beautiful watercolor paper.

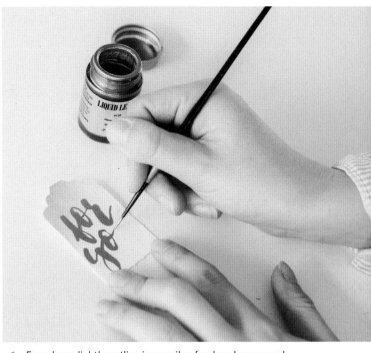

5 Once you've cut out your tags, prep your ink, paint, liquid leaf or other medium to get ready for your gift tags! I used a small liner brush and liquid metallic leaf for these tags.

6 From here, lightly outline in pencil or freehand your words with your brush. Remember to "push" your downstrokes and "pull" your upstrokes with your brush.

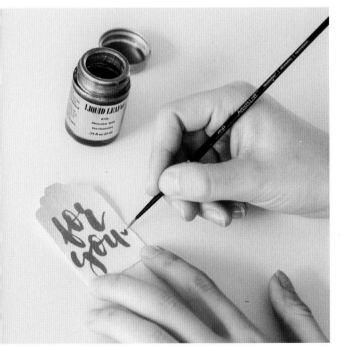

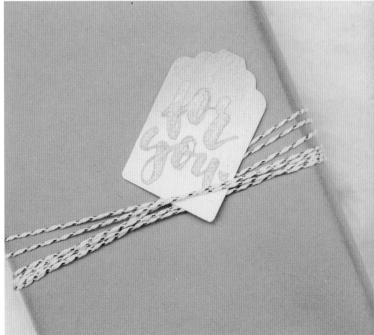

7 Finally, add a few decorative elements if needed. I just added a simple heart in place of a period. Because the watercolor is so beautiful, you don't want to hide too much of it with decorative elements.

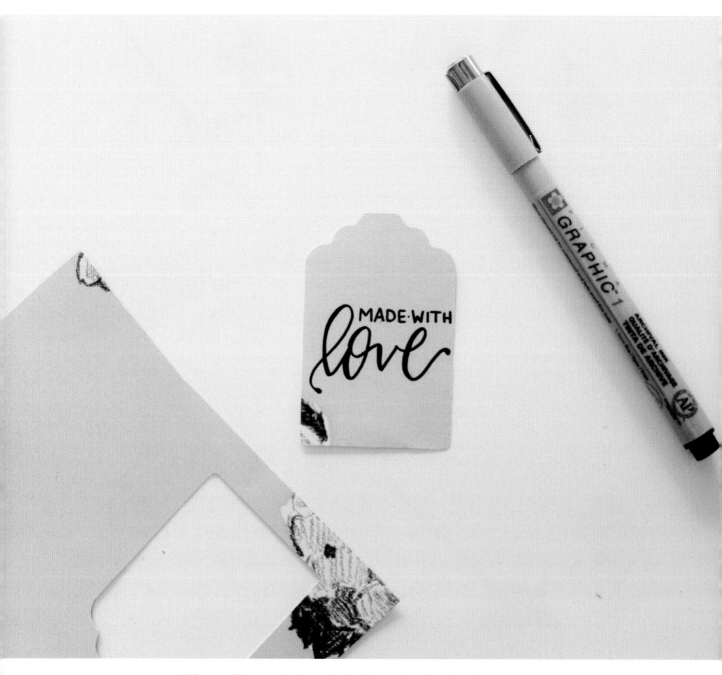

With your gift tag punch, it is really simple to create unique tags from any paper that catches your eye. Whether it's a photograph, ephemera, scrapbook paper or even old letters, using your gift tag punch will make each completely unique! For this variation, I used a piece of scrapbook paper and, mixing my sans serif font with cursive lettering, created a "Made With Love" tag using Micron pens.

Creating gift tags doesn't always require a fancy punch or stencil. Simply use a pair of scissors to cut your tags in the size you desire. In this variation, I cut watercolor paper to my desired size and used my watercolor brush and paint to make simple tags, each with a different phrase.

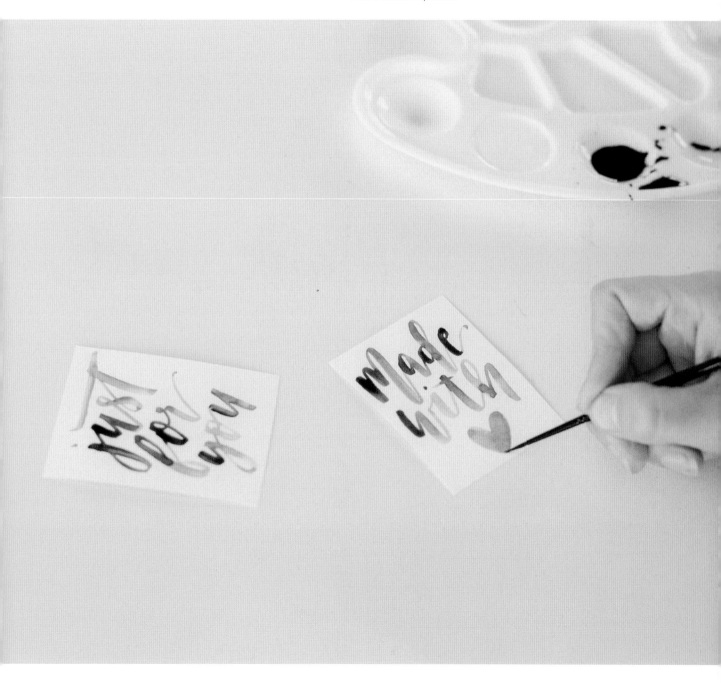

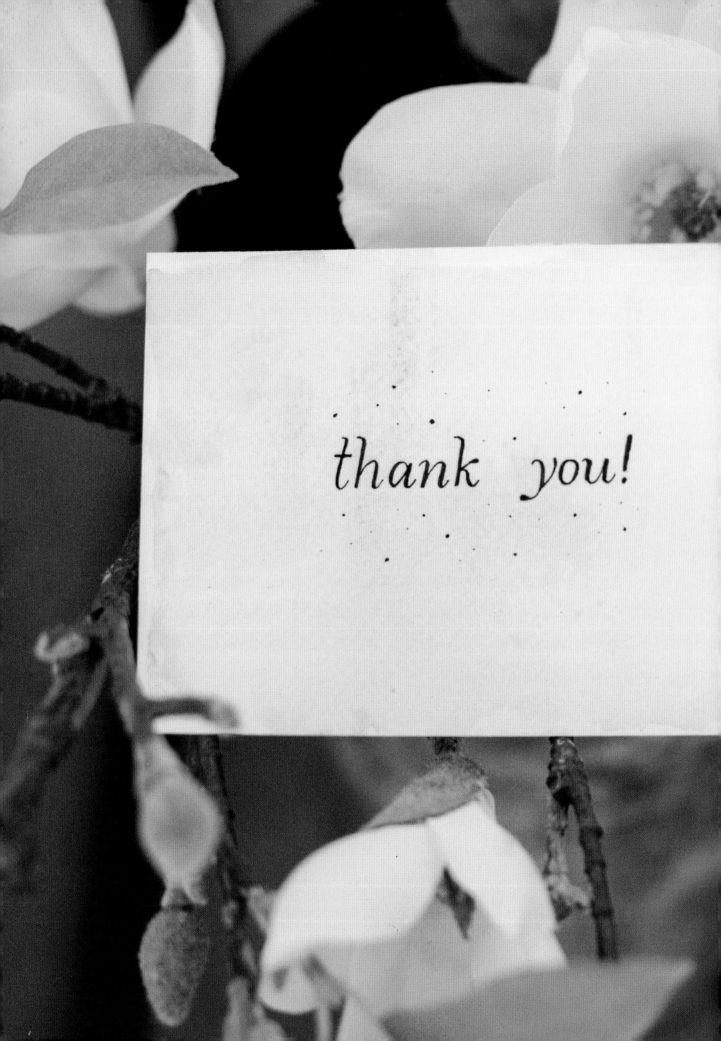

Thank-You Card

With how quick-paced life is, receiving thank-you notes has become relatively uncommon. A small note, however, can completely brighten someone's week and make her feel truly valued and loved! This project is just for that—sending someone a simple "Thank You" to ensure she feels recognized and cared for.

WHAT YOU NEED

eraser
liner brush
Micron pen
pencil
paper towel
watercolor, color of your choice
watercolor brush (and cup of water)
watercolor paper (or cardstock)

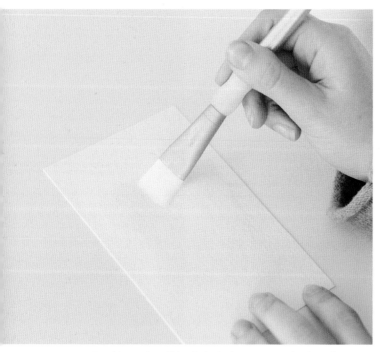

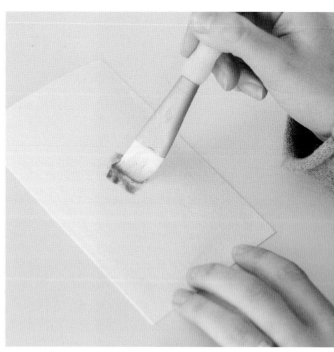

1 For this card, we'll begin by laying a watercolor base for our text to go on top of. Start by creating a clean water wash across your entire card. The more water you use, the easier it will be for your color to bleed.

2 Next, take a dab of concentrated color and, starting in the center, create your color bleed by lightly tapping and moving your color around from the middle outwards. Tilt your card to move your color around even more.

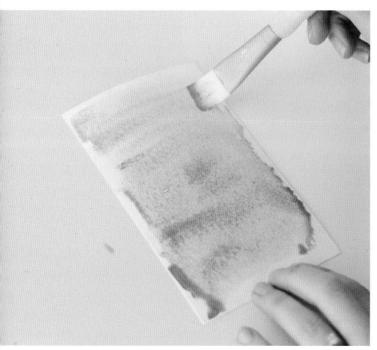

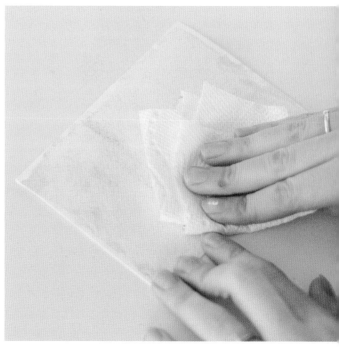

3 Optionally, you can brush your color across your card to create a different look. In this example, I went from top to bottom, left to right and went back over it with my brush to reduce the amount of bleeding on the edges.

4 After letting your watercolor dry for a few minutes, take a clean and dry paper towel and dab your paper to absorb any remaining wet watercolor. This helps create a soft and textured look.

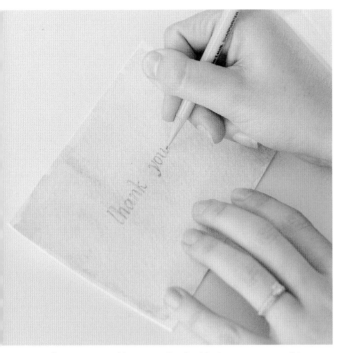

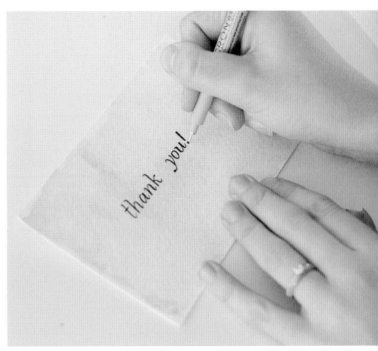

5 Once your card has completely dried, use your pencil to very lightly sketch out your *thank you*. I chose to use an all lowercase italic serif to pair with the delicate color and texture of the card.

6 Next, trace over your pencil markings with your pen. Start with a fine-tip pen and build your lines with thicker ones as you see fit.

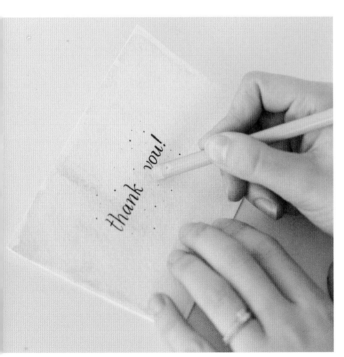

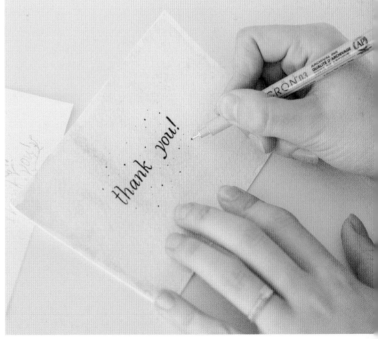

7 Once you've traced over your pencil marks, very gently erase any pencil lines you can still see. It's very important to use just a small amount of pressure on your eraser here so you don't erase your watercolor background.

8 Finally, add a few decorative elements if needed. I roughly sketched my *thank you!* on a sheet of paper so I could play with a few different ideas before committing to one. In the end, I chose some really simple dots in different sizes to surround my note like stars.

Here's a modern variation of our thank-you card that is super simple to create but really beautiful. For this card, I created a clean water wash on the bottom left corner of my card and started my color bleed in the bottom left corner, slowly working the color outward. While the watercolor is still wet, lightly drop some gold leaf flakes onto your color. Once the watercolor dried on its own, I added my *thank you!* to the top right corner after sketching out a few different styles on a piece of scratch paper.

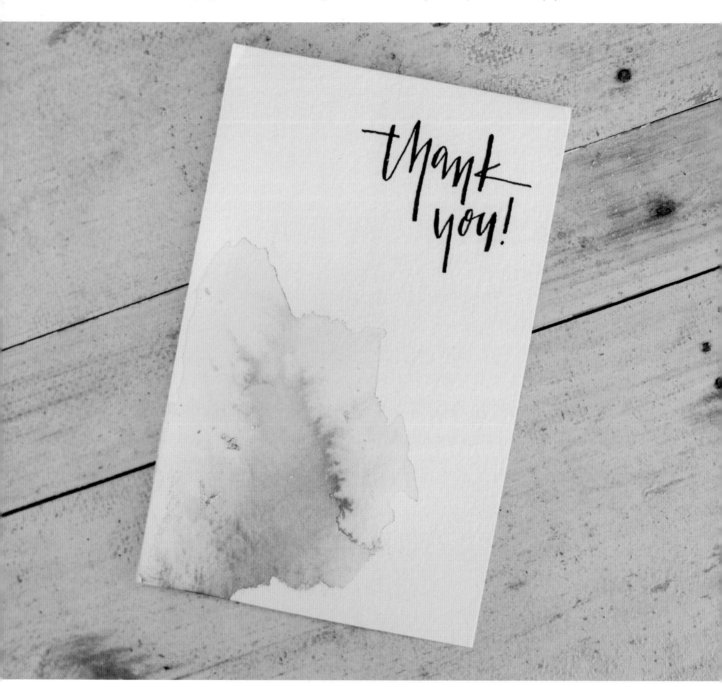

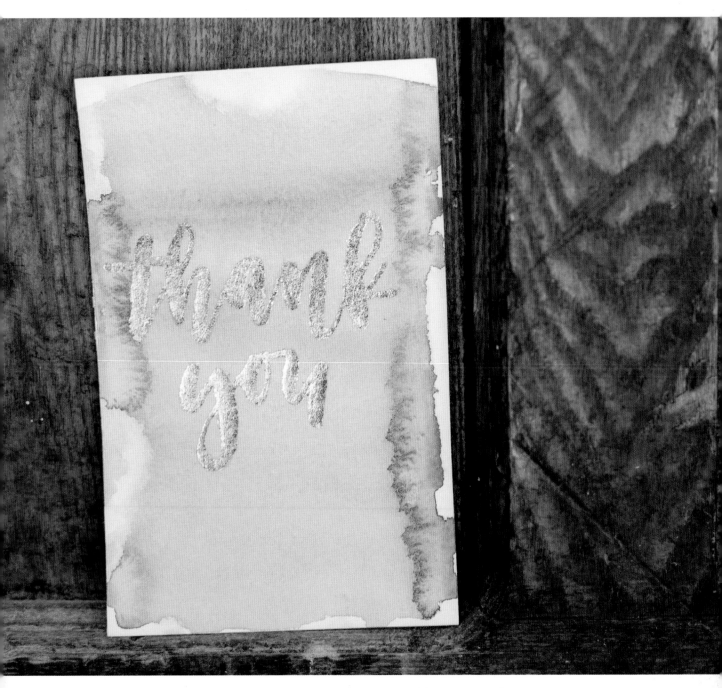

This variation uses gold leaf to create gorgeous texture and shine to your card. I began with a clean water wash on my entire card and used diluted black watercolor to create the gray background. Then, in the process on the following pages, I created my *thank you* using gold leaf.

Gold Leaf

Using gold leaf to accent your lettering is a gorgeous and elegant way of making your project stand out. It also adds an extra handmade touch to make your recipient feel really special. In this section, we'll explore how to add gold leaf to our thank-you cards, but the technique applies to any project you want to add some sparkle to.

WHAT YOU NEED

gilding adhesive

gold leaf

liner brush

paint palette

watercolor brush

watercolor paper
 (prepped with watercolor
 wash and dried)

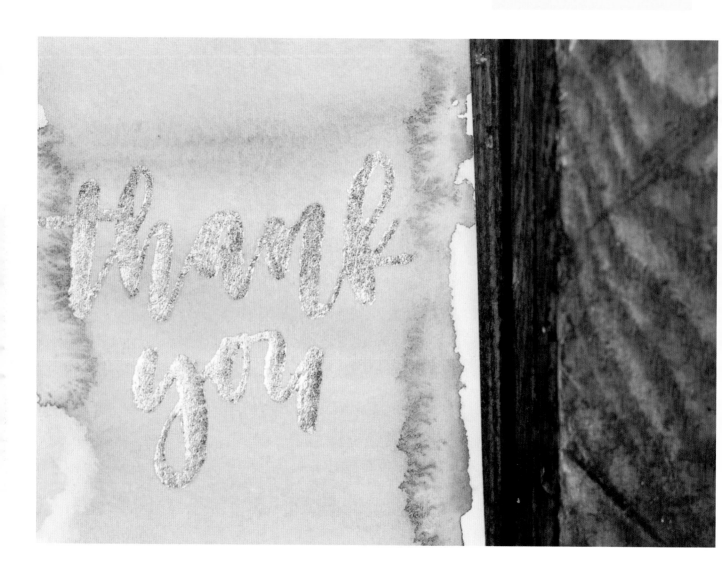

 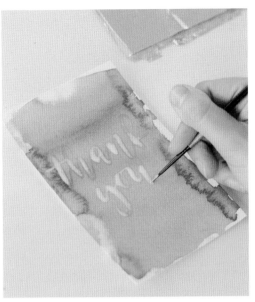 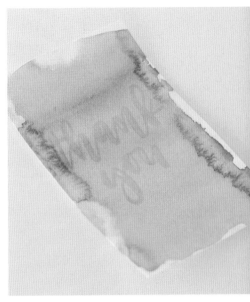

1 Begin by pouring some of your gilding adhesive into a section on your paint palette. Using your adhesive like paint will make it much easier to compose your phrase with a liner brush.

2 Using your adhesive as if it were paint, write your *thank you* onto the card in your style of choice. I chose to do mine in cursive lettering.

3 Once you've written out your *thank you,* allow the adhesive to completely dry. As you can see, it will dry totally clear.

4 Take your gold leaf sheet and press it into each line of your lettering. After a thorough job is done, you'll be able to see a slight outline of your lettering. Make sure to push the foil into each stroke so you don't end up missing sections of your words.

5 Using a dry brush, begin to brush away large sections of the gold leaf. Start with the largest sections and work your way to the smaller ones.

6 Finally, use your dry brush to brush away the more detailed sections of your lettering. For the inside loops of the *a, k, y* and *o,* I needed to use my fingernail to start peeling the leaf away so my brush could do the rest. Keep your brush at a low angle so it scrapes the leafing away more easily. Then, lightly brush away any extra around the edges and give your card away!

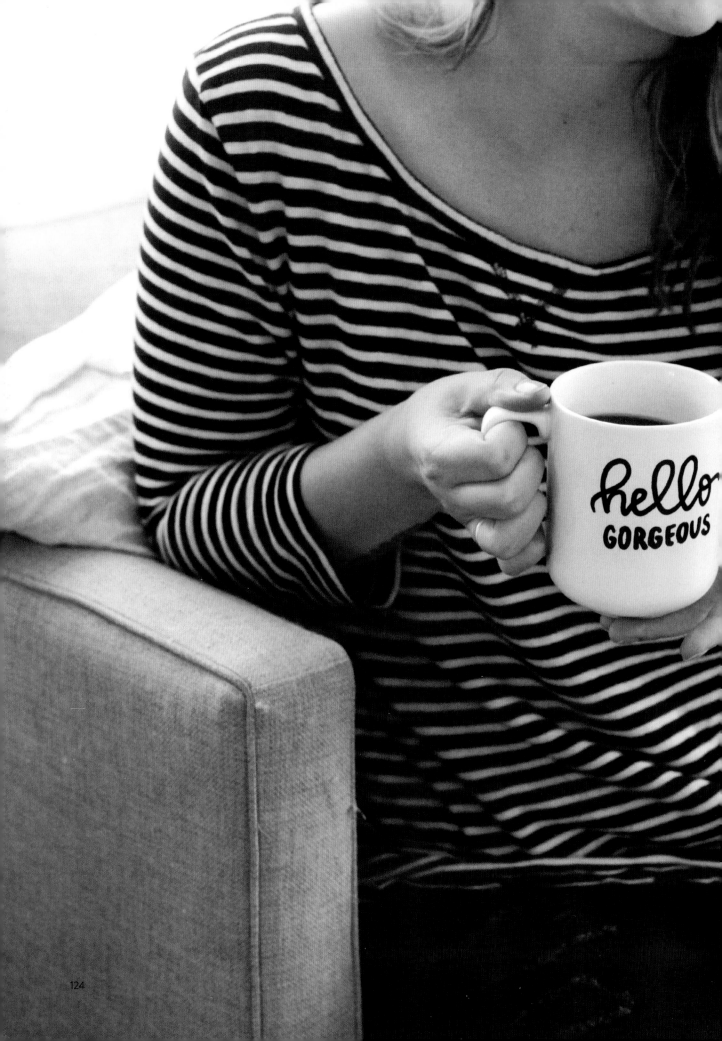

Coffee Mug

Morning: For some, it comes with daunting lists of tasks, to-dos and missing shoes; for others, it's the only quiet they'll find during their busy day. Whatever your mornings look like, it's important to feel equipped, empowered and ready to take on the day. So why shouldn't the first thing you grab in the morning (ahem, coffee!) also throw out a nice compliment? Hello, GORGEOUS!

Now, make yourself a French press of your favorite coffee blend, grab a good book and enjoy your new mug that greets you with a wink and a smile!

WHAT YOU NEED

coffee mug
oil-based paint pen
oven
paper towel
pencil, 4H (or charcoal)

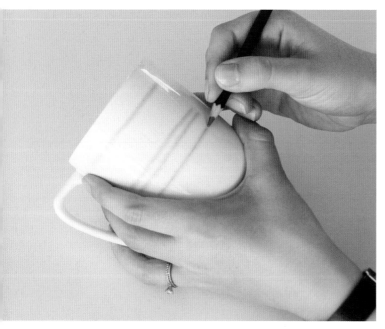

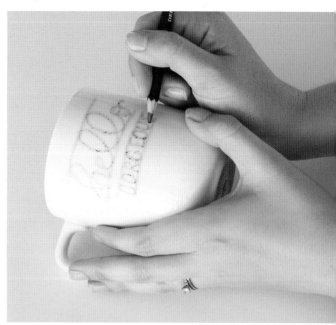

1 Using a dark 4H pencil or piece of charcoal, create your baseline and ascender line for each word in your phrase. This is where envisioning your piece comes in handy. I wanted *hello* to be bigger and *GORGEOUS* to be smaller, so my baseline and ascender lines reflect that intention for each word.

2 Next, begin pencilling in your words. This is where it's completely okay to make mistakes—all you need to do is wipe off the lead and try again. From here, we'll be tracing with our oil-based permanent paint pen, so be sure it looks the way you want it to look as a final product.

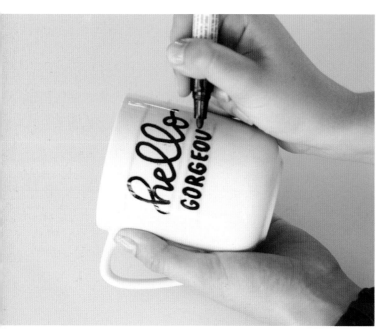

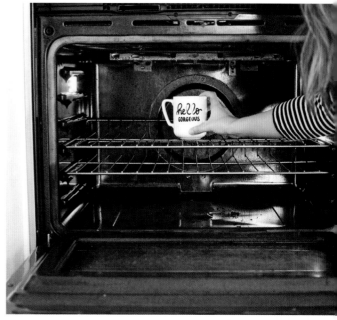

3 Using your oil-based paint pen, trace over your pencil marks to create your artwork. You can use the downstroke calligraphy technique here if you like, but I chose to leave it simple because of the thickness of the marker and relative minimalism of the mug. Decorative elements are also welcome—add whatever elements are completely and totally you!

4 After letting your paint dry, gently wipe off your pencil marks. Then, place your mug in an oven preheated to 350º for 30 minutes. Once 30 minutes is up, turn the oven off and let your mug completely cool inside. This process will enable the ink to set so it becomes more permanent and resistant to washes. This still doesn't make it entirely dishwasher safe. Setting the ink will make your design last longer through the dishwasher; however, it is still best to hand wash your mug to be completely safe.

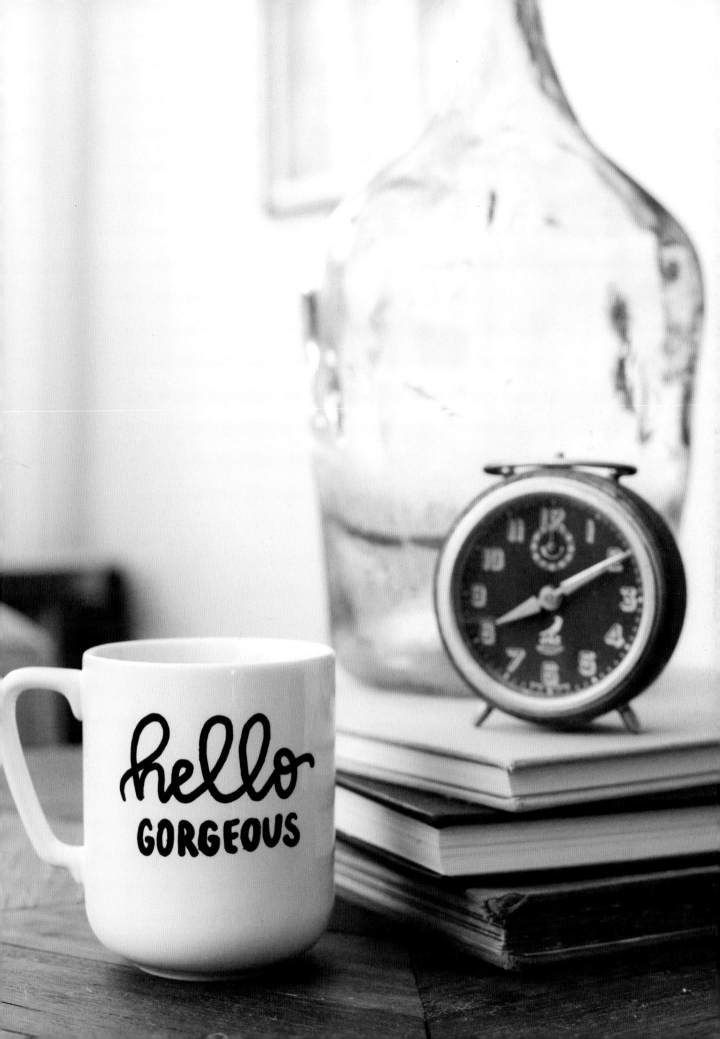

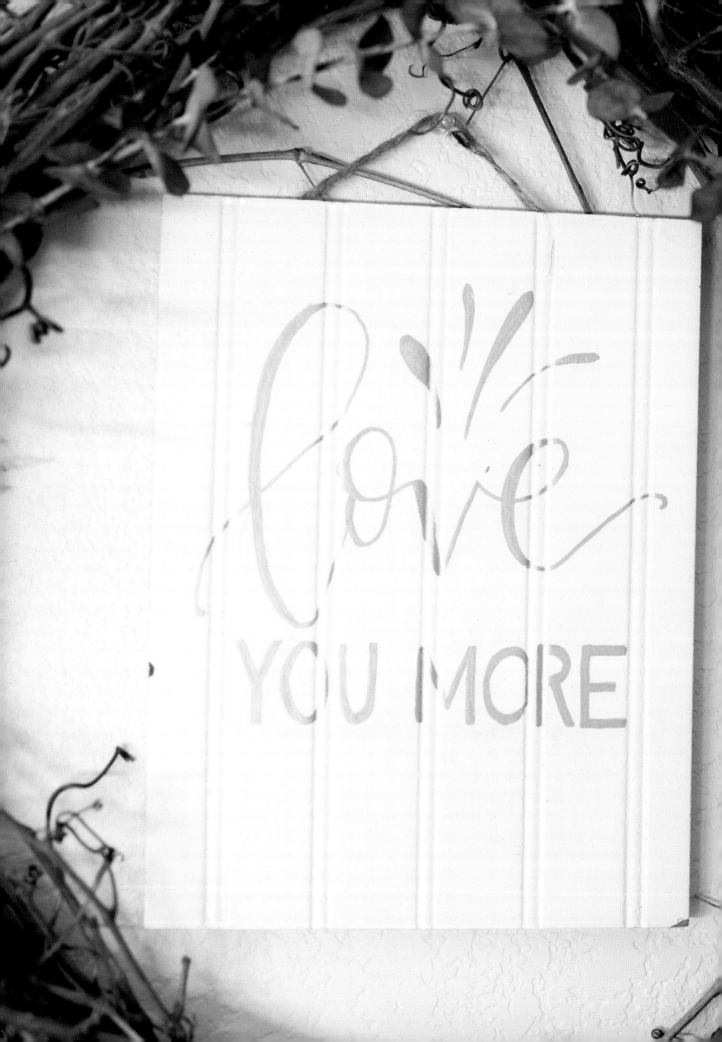

Decorative Sign

Adding calligraphy to signage has made for some of the greatest gifts I've been able to give to others in the past—from wedding signs the couple can hang in their home after the wedding to menu boards for small businesses. It's an incredibly fun and unique gesture to give the gift of intentionally visible encouragement. So, without further adieu, let's get started on our signs!

WHAT YOU NEED

eraser

gold leafing pen

pencil

straightedge

wood board

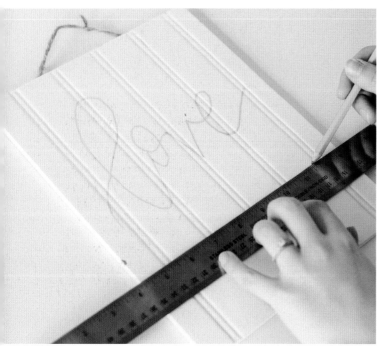

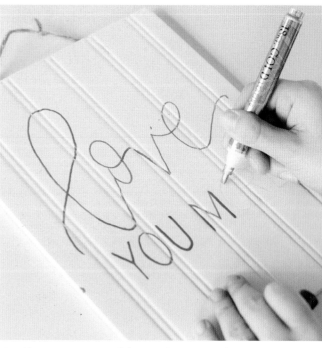

1 To start your sign, use a pencil and straightedge to create your guidelines. Begin to freehand your words or use your guides and blocking technique to start forming your phrase.

2 Next, erase your guidelines and use your gold leafing pen to trace over the penciled letters that remain. It doesn't have to look perfect yet. We'll go over each letter in the next step to make them look a bit smoother.

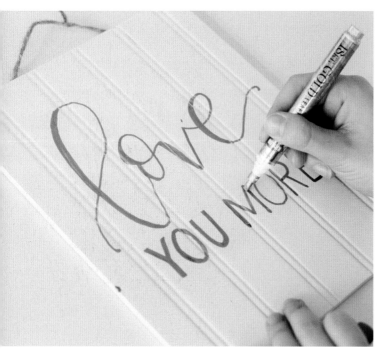

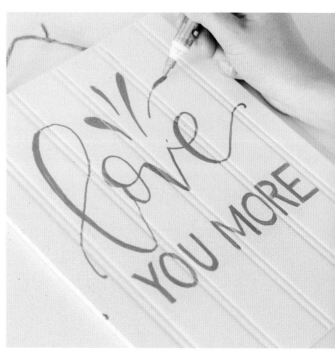

3 After you've drawn over your penciled lines, go back over your letters with your gold leafing pen, creating down-strokes for your calligraphy letters and thickening the strokes overall for your printed letters.

4 Lastly, add some simple decorative elements to create a more finished look for your sign.

White paint on wood signs creates a beautiful elegance that is gorgeous in just about every setting. For this sign, I used a pencil to create my phrase and an acrylic white paint marker to go over my lines. Sometimes, wood will absorb your paint quite a bit, so don't be afraid to work in layers. This sign took about three layers with this paint marker to get a good opaque color.

Small blank signs like these are available at many major craft stores and are perfect for collage walls, mantels and other decorative settings. It's definitely easier to start small and work your way up to bigger signs.

This sign is just a 2' × 4' (61cm × 122cm) piece of plywood I stained and oiled. Then, I took a chalk marker and drew *welcome* and my branch elements. After allowing it to dry, I lightly drew out my word and branches with a pencil. Then, I went over everything with a paintbrush and some white acrylic paint to make the color pop.

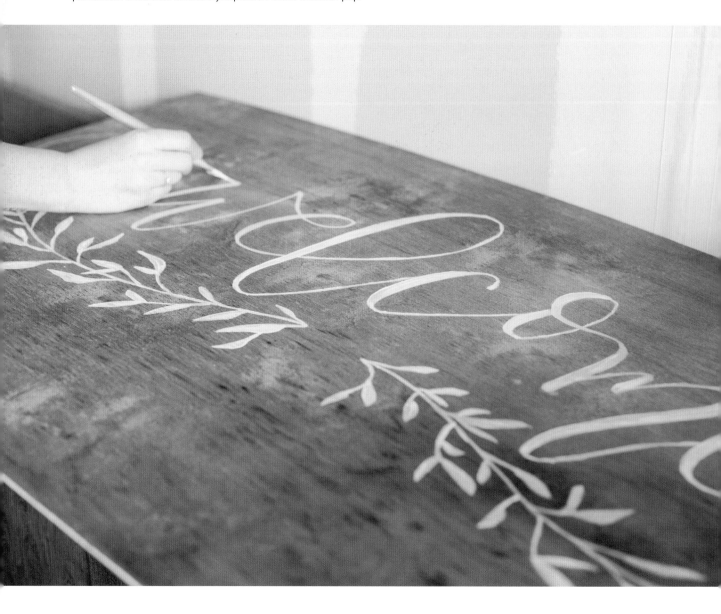

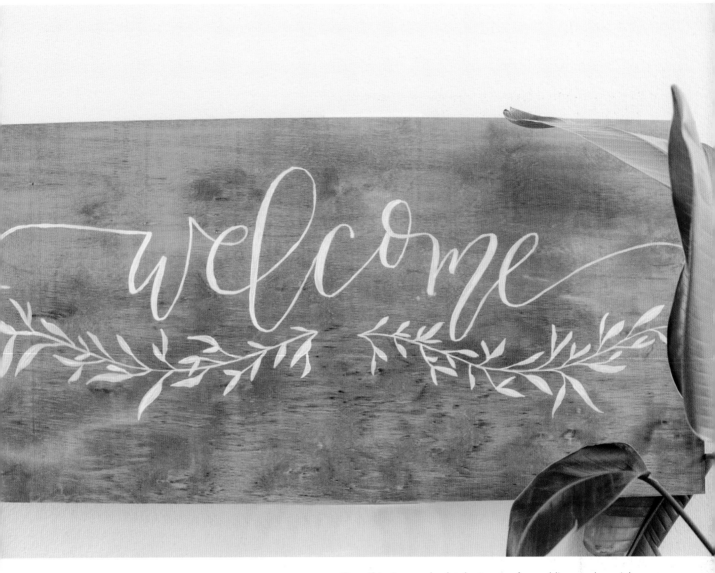

Signs this size are absolutely stunning for weddings and special events, but can even be mounted on your entryway wall with a frame mounting kit (assuming your sign is lightweight).

Wall Mural

Here's where we can really put our Digitizing lesson to work! Our mural project will start with a smaller-scale concept on paper, then we'll blow it up on the wall with a projector. This technique helps make the process a bit more approachable.

WHAT YOU NEED

acrylic paint
Adobe Photoshop software
camera or scanner
computer
paintbrushes, flat, 1", 2", 3"
 (25mm, 51mm, 76mm)
paper
pencil
projector
plastic container (for paint)

1 To begin your mural, start by creating your artwork on a piece of paper in the size of your choice. Keep in mind, the bigger your paper, the more detail you'll be able to create.

2 Once you complete your artwork, scan it to your computer using either a scanner or your camera. You'll want to make sure, however, that the quality is high—it will distort (pixelate) when it's projected if the quality is not high enough, and that just makes things more difficult in the long run. Using the process described in the Modern Lettering section, digitize your artwork.

3 Now you can set up your projector with your new artwork. Generally, you'll need either a very high-power projector for brighter spaces or you'll need to wait until night to create your outlines. Depending on your projector, you may need to flip your image horizontally. You can do this in Photoshop (Image > Image Rotation > Flip Canvas Horizontal).

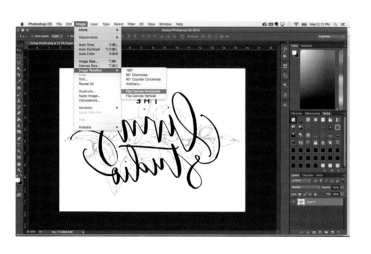

4 Move your projector either closer to your surface to make it smaller or farther away to increase the size. Use the focus dial on the lens to make sure your image is clear.

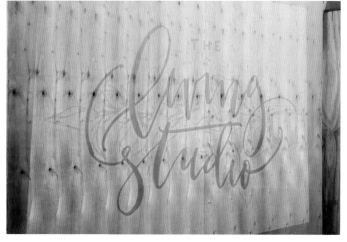

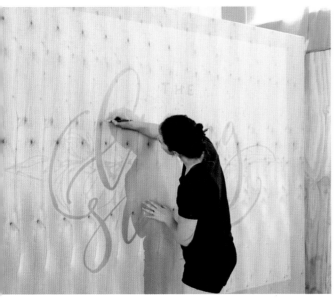

5 Once your projector is set up, take a pencil and begin forming your outlines. This process takes a while, so be patient! I generally work from top to bottom and left to right to help keep me from missing any spots. If you're painting with multiple colors, you can label each outline section with different numbers coordinating with each color to help keep you organized. When you're finished, your artwork will almost appear like a coloring book, showing you where you need to simply paint inside the lines.

6 If you're painting with multiple colors, begin painting with one color at a time. I usually love (and need) to see progress, so I start with the greatest quantity of color first. In this case, that's the black paint for my lettering.

Pour some acrylic paint in a bowl or plastic container. If you're mixing your paint, do it all at once in a resealable container so your color is the same across your painting.

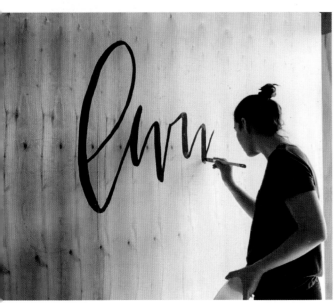

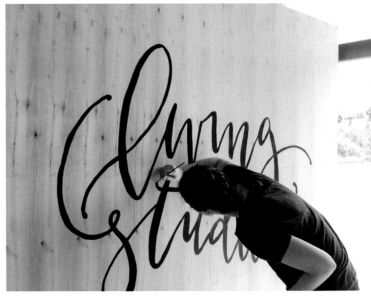

7 After you've prepped your paint, begin painting each section using your 1" (25mm), 2" (51mm) and 3" (76mm) flat brushes. I use the 3" (76mm) brush for filling my letters and a smaller 1" (25mm) brush for line and detail work. I also work the same direction for each section and color—top to bottom, left to right.

8 Once you finish painting in your main color, begin going back through each section to clean up your lines, ensuring your penciling is covered and your lines are smooth. If there are sections where your wall color pokes through, go over them with another coat of paint until it is completely opaque. Then, begin your subsequent color sections.

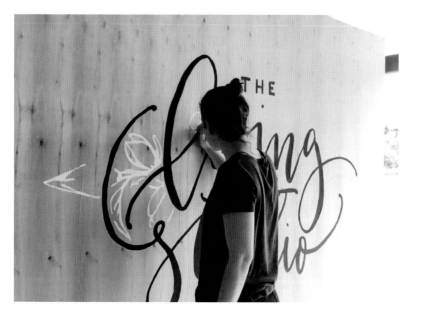

9 After you've filled in each section of your main color, move on to your remaining ones, keeping your painting direction in mind. For the detailing, I used a much smaller brush to get clean and accurate lines. Finish all your remaining sections and clean up your lines.

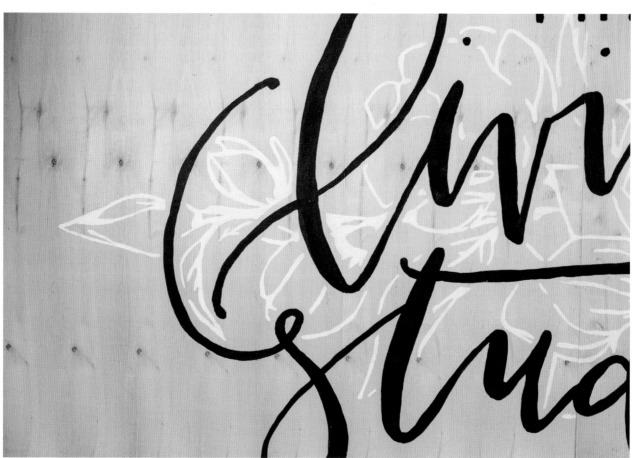

You did it! This is certainly the most time-consuming project, but it is so worth it. Now, move your furniture around so the focal point is on your beautiful new mural!

Conclusion

We're finally here, at the end of our time learning together. This isn't, however, the end of your learning! Please take what you've learned here and practice. Lettering is difficult and often takes a while to get really comfortable with it, so please don't give up on yourself. Continue giving your practice projects away to others, whether it's in the form of a gift, a note or just helping create an environment where people feel loved on.

Remember as well—this is for you! If you're having an amazing day, write down your favorite part in a fancy script. If you feel down, write an encouraging reminder to yourself and put it somewhere you can see it clearly. If you just need a break from your day-to-day life, take ten minutes and focus on nothing but your brushstrokes or letters. Whatever you do, try to remember that this new skill can be used to encourage yourself as well as others.

Steven Pressfield says in his book *The War of Art*, "The more important a call to action is to our soul's evolution, the more Resistance we will feel about answering it. But to yield to Resistance deforms our spirit. It stunts us and makes us less than we are and were born to be." Odds are, it will be most difficult to take out your brushes or pens when your soul needs it the most. Maybe the phone won't stop ringing, you can't find the ability to focus, something in the kitchen falls over and spills everywhere. Something will inevitably try to get in the way of your growth when it matters the most. So persevere. Keep pressing forward to silence that voice within you that may mock you every time you pick up a brush. The more times you conquer it, the quieter it'll become.

My friends, thank you so much for learning with me! I hope this isn't the end of your lettering journey, but only the beginning!

Jen Wagner

P.S. It would bring my heart so much joy to see your art! Use the hashtag #HappyHandLettering on your social media so we can all see your progress and beautiful work!

Index

With Thanks . . .

Jesus—my dream maker. I'm grateful that you love me as I am and that you hear the soft whispers of my heart. I'm proud that I am who I am because of all you've done and who you are to me. When words fail you're still near.

Aaron, thank you for your daily inspiration, your unending patience and your constant encouragement. There are a lot of things in life I would not have said "Yes" to were it not for your faith in me. You've always pushed me to be better, to do things that scare and challenge me and to find joy in every moment of the process. On my worst days you have never hesitated to lift me up and remind me that who I am is not what I do. Your constant reminders of my identity in Christ have inspired a new self-confidence that comes with the freedom of separation of self from performance. You're the reason I'm here writing this. Thank you for loving me so well that the joy of even our mundane moments together outweighs that of our wedding day. Thank you for always encouraging me to take risks and jump. Thank you for doing this crazy life with me. Love you always.

To my friends and family: Mom, Dad, thank you for always encouraging me to create. From piano lessons to coloring-book contests with Mom and all kinds of art books and supplies from Dad, I'm grateful to have grown up in a family that refused to belittle creativity. Chris and Taylor, I'm glad we were able to spend all that time together as kids drawing and painting and exploring. Those memories are still priceless to me. Steve and Lana, thank you for all of your kind words, your patience with me when I'm lost in my thoughts and for raising such an amazing son. My sister Heather, you have such a wise and gentle way of pulling me out of whatever stress I feel and reminding me that there is so much life between the lines. Thank you for inspiring me to live well. Jeannie and Lindsay— my Medic sisters—thank you all for being so steady. I'm grateful to have friends who have even more rapidly become sisters to me. To the church staff at The Rock, your relentless encouragement has helped silence any fear that has come up in the months creating this book. To have such a scary thing celebrated so fearlessly silenced the voice of fear quickly.

Jeanne—this would literally not have happened without your unfaltering belief in me. Thank you for your incredible patience, relentless support and unfading confidence in me. I love you very much and am so excited to continue creating together.

a content + ecommerce company

Other fine North Light Books are available from your favorite
bookstore, art supply store or online supplier. Visit our website at
fwmedia.com.

21 20 19 18 17 5 4 3 2 1

Distributed in Canada by Fraser Direct
100 Armstrong Avenue
Georgetown, ON, Canada L7G 5S4
Tel: (905) 877-4411

Distributed in the U.K. and Europe
by F&W Media International LTD
Pynes Hill Court, Pynes Hill, Rydon Lane,
Exeter, EX2 5AZ, United Kingdom
Tel: (+44) 1392 797680
Email: enquiries@fwmedia.com

ISBN 13: 978-1-4403-5093-1

Edited by Tonia Jenny
Designed by Clare Finney
Production coordinated by Jennifer Bass

ABOUT JEN WAGNER

Jen Wagner is a multifaceted creative from Southern
California. Raised in an entrepreneurial and creative
home, Jen has from a young age been starting suc-
cessful businesses and creative endeavors of all kinds.
She has made her mark internationally doing branding,
design, photography, interior design and hand lettering
for businesses and brands—large to small.

Partnering with Jeanne Oliver Designs, Jen has
made her way into speaking and e-courses, teaching
women how to be empowered and inspired through
several different mediums.

Jen and her husband, Aaron, currently reside in
Nashville with their dog, Kingsley, and make it a point
to drink good whiskey, make friends and travel often.
For more info, go to www.jenwagner.co.

Ideas. Instruction. Inspiration.

Receive FREE downloadable bonus materials when you sign up
for our free newsletter at ArtistsNetwork.com.

Find the latest issues of *Cloth Paper Scissors* on newsstands, or visit shop. clothpaperscissors.com.

These and other fine North Light products are available at your favorite art & craft retailer, bookstore or online supplier. Visit our websites at artistsnetwork.com, northlightshop.com and artistsnetwork.tv.

 Follow ClothPaperScissors for the latest news, free wallpapers, free demos and chances to win FREE BOOKS!

Get your art in print!

Visit artistsnetwork.com/category/competitions
for up-to-date information on *AcrylicWorks* and
other North Light competitions.